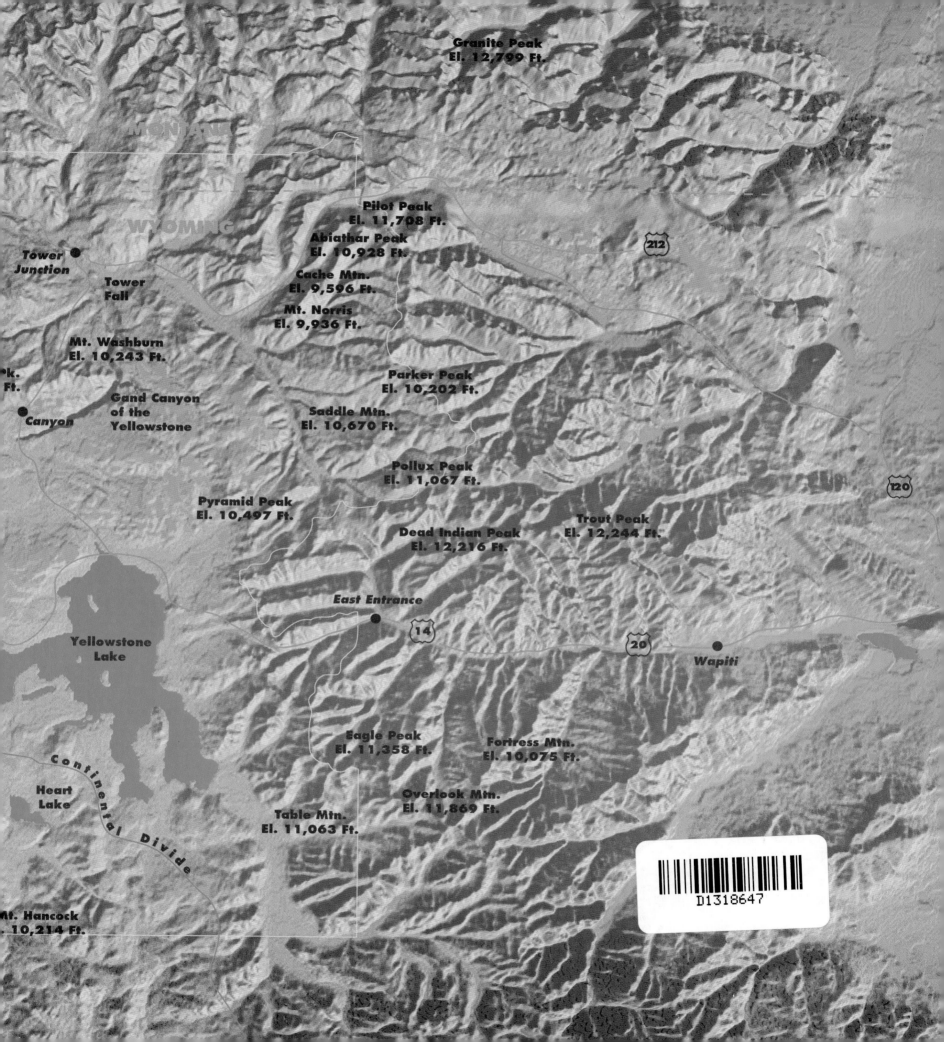

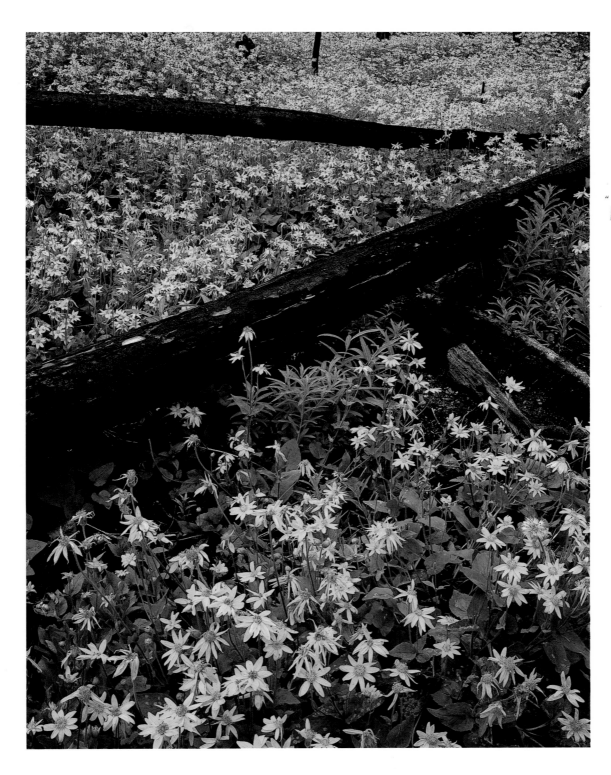

"Standing in the midst of hot pots, wild gorges, and whitecapped mountains, it seemed that heaven, earth, and hell were all here in this one place, bound by the vertical stitchery of rain, snow, fire, and steam."

GRETEL EHRLICH

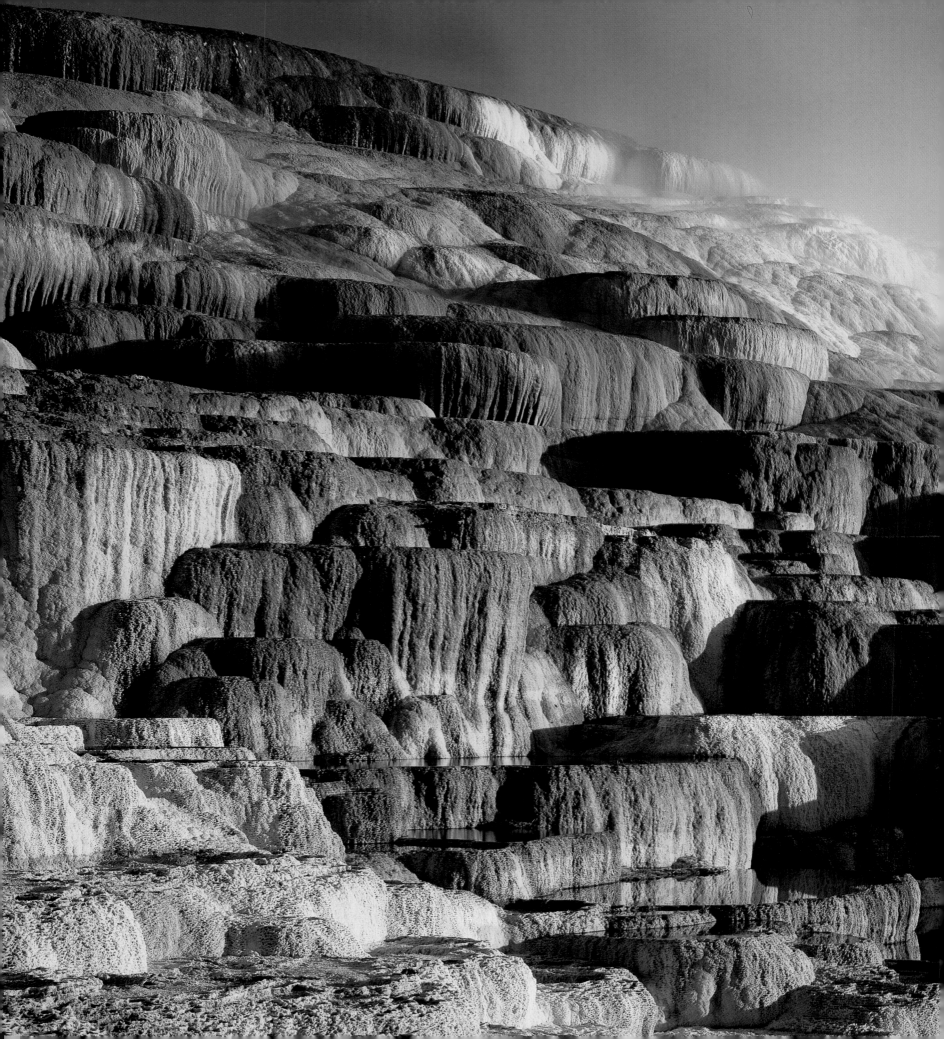

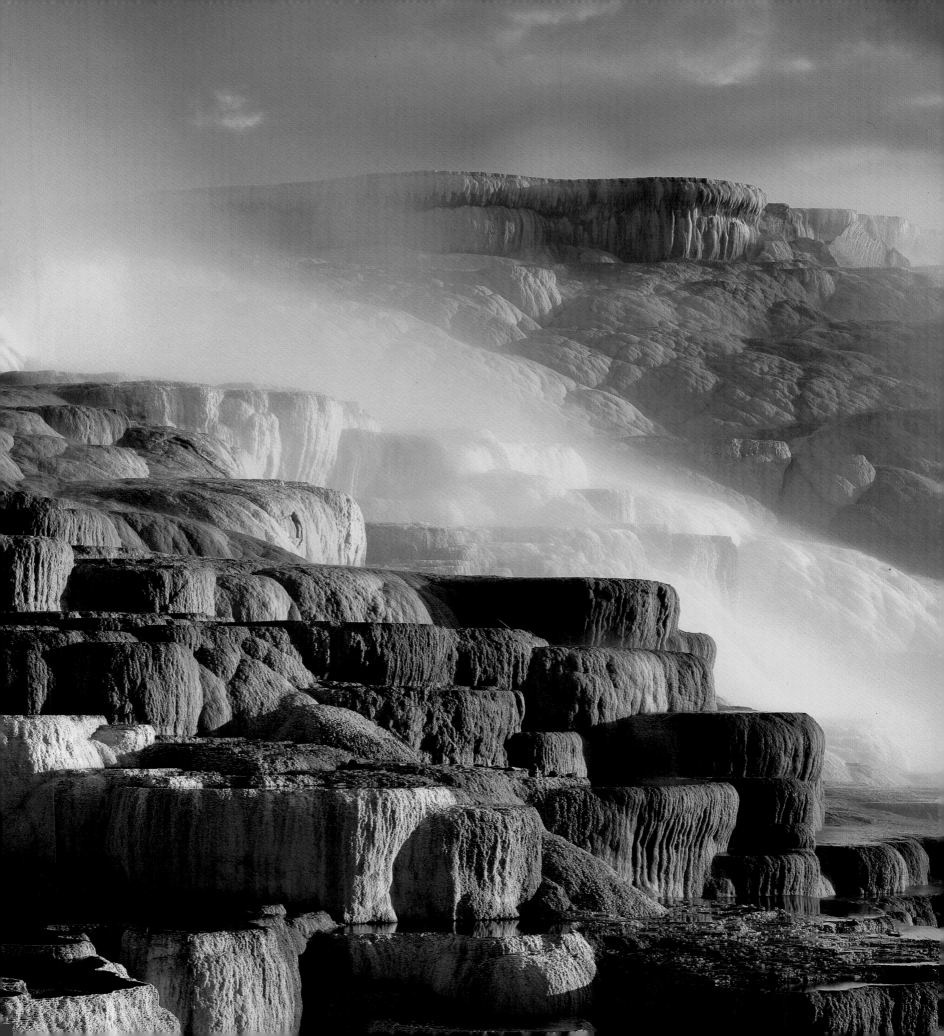

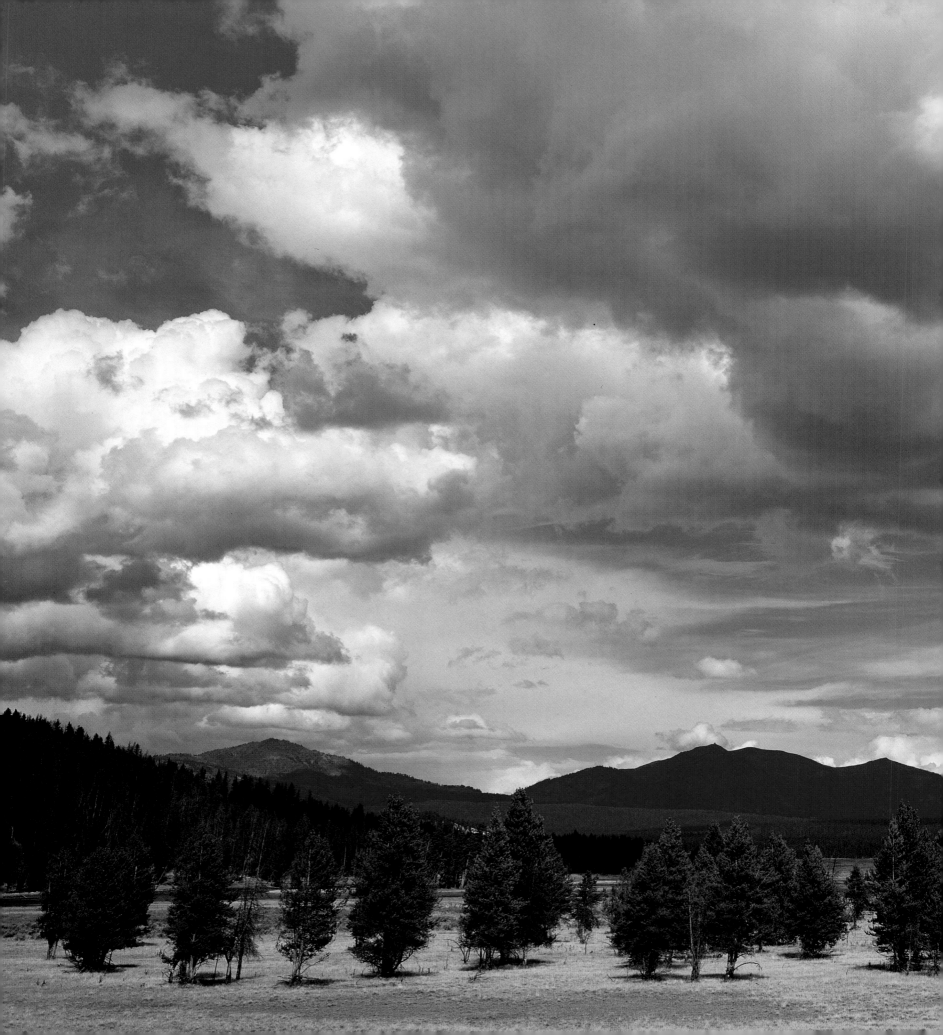

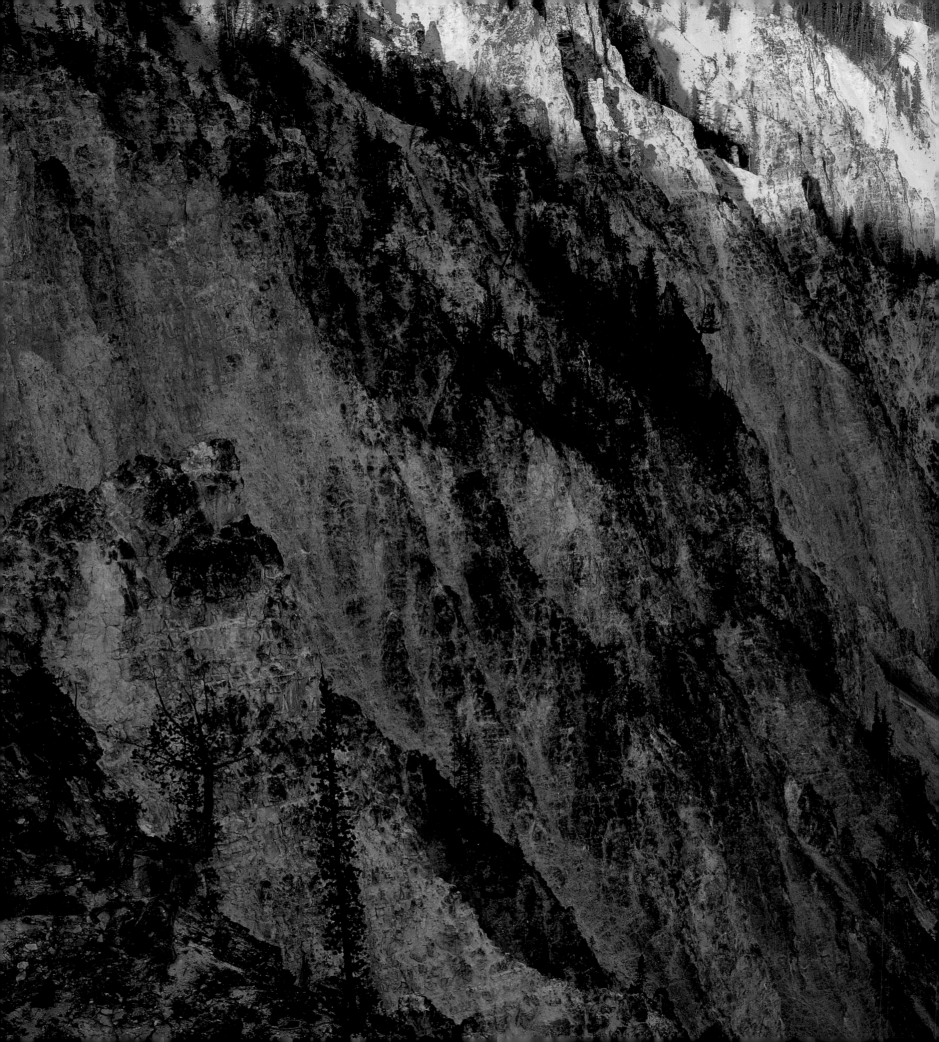

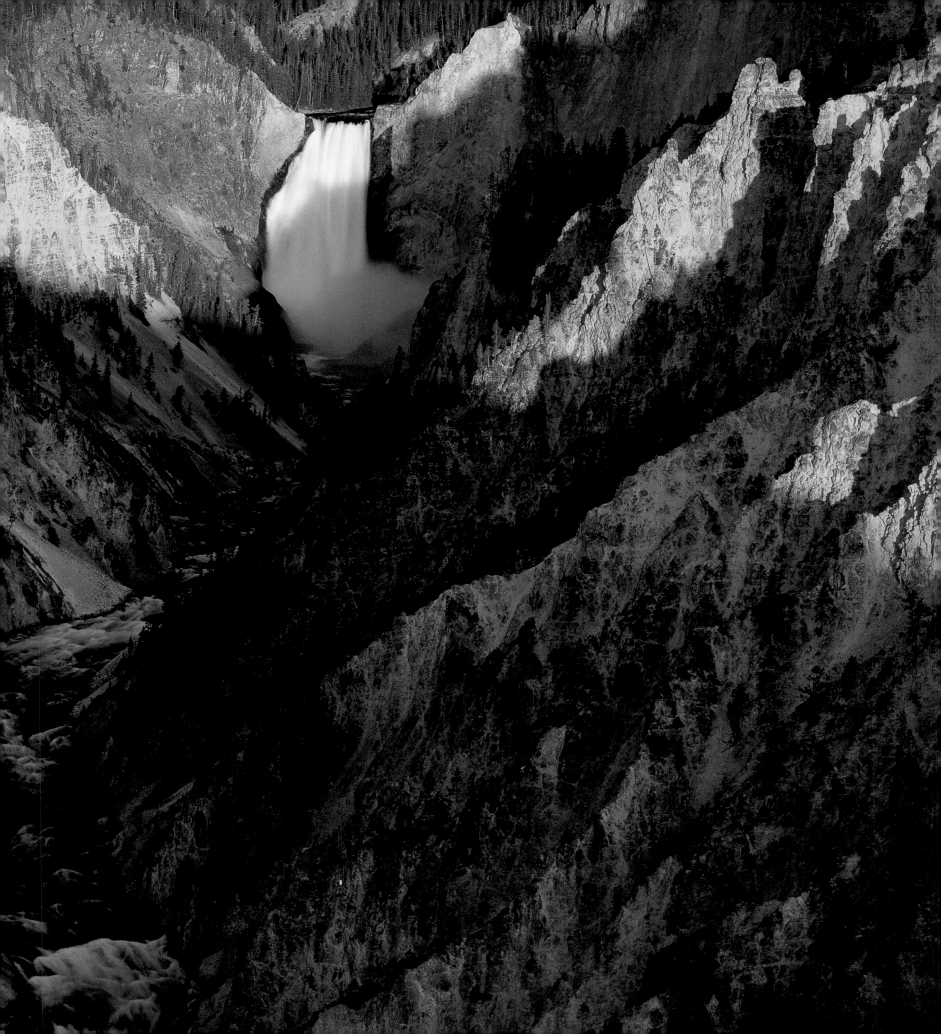

YELLOW

LAND OF FIRE

GRETEL

PHOTOGRAPHY BY

HarperCollins**West** *A Division of HarperCollinsPublishers*

STONE

AND ICE

EHRLICH

WILLARD AND KATHY CLAY

A Tehabi Book

Page 1:

M*eadows of wildflowers bloom below the spent volcano of Mt. Washburn.*

Pages 2-3:

Morning light on Canary Springs at Mammoth Terrace. Heated groundwater dissolves calcium carbonate in the layers of exposed limestone, creating the rock's frothy white texture.

Pages 4-5:

Storm clouds gather over the Hayden Valley.

Pages: 6-7:

Dark canyons turn gold as the sun rises over Lower Falls in the Grand Canyon of the Yellowstone.

Pages 8-9:

Ledge Geyser erupts in Porcelain Basin. Minerals, algae, and reflections from the sky create a palette of colors in nearby pools.

The Genesis Series was conceived by Tehabi Books and published by HarperCollinsWest. The series celebrates the epic geologic processes that created and continue to shape America's magnificent national parks and their distinctive ecosystems. Each book is written by one of the nation's most evocative nature writers and features images from some of the best nature photographers in the world.

Yellowstone: Land of Fire and Ice was produced by Tehabi Books. Susan Wels, *Genesis Series Editor*; Jeff Campbell, *Copy Editor*; Anne Hayes, *Copy Proofer*; Nancy Cash, *Managing Editor*; Sam Lewis, *Art Director*; Tom Lewis, *Editorial and Design Director*; Sharon Lewis, *Controller*; Chris Capen, *President*.

Written by Gretel Ehrlich, *Yellowstone: Land of Fire and Ice* features the photography of Willard and Kathy Clay. Supplemental photography was provided by Tom and Pat Leeson (page 100) and Tom Mangelson (pages 84, 88-89, 93, 94-95, 99, 100, and 101). Technical, 3-D illustrations were produced by Sam Lewis. Source materials for the illustrations were provided as digital elevation models from the United States Geological Survey. Additional illustrations were produced by Andy Lewis and Tom Lewis.

For more information on Yellowstone National Park, HarperCollinsWest and Tehabi Books encourage readers to contact the Yellowstone Natural History Association, P.O. Box 117, Yellowstone National Park, WY 82190; (307) 344-2293.

HarperCollinsWest and Tehabi Books, in association with The Basic Foundation, a not-for-profit organization whose primary mission is reforestation, will facilitate the planting of two trees for every one tree used in the manufacture of this book.

Library of Congress Cataloging-in-Publication Data

Ehrlich, Gretel

 Yellowstone : land of fire and ice / Gretel Ehrlich. — 1st ed.

 p. cm. — (Genesis Series)

 Includes index.

 ISBN 0-06-258572-X (cloth). — ISBN 0-06-258559-2 (paperback).

 1. Natural history — Yellowstone National Park Region.

I. Title. II. Series: Genesis series.

QH105.W8E48 1995

917.87`520433-dc20

 94-43212

 CIP

95 96 97 98 TBI 10 9 8 7 6 5 4 3 2 1

This edition is printed on acid-free paper that meets the American National Standards Institute Z39.48 Standard.

THE GENESIS SERIES
YELLOWSTONE
LAND OF FIRE AND ICE

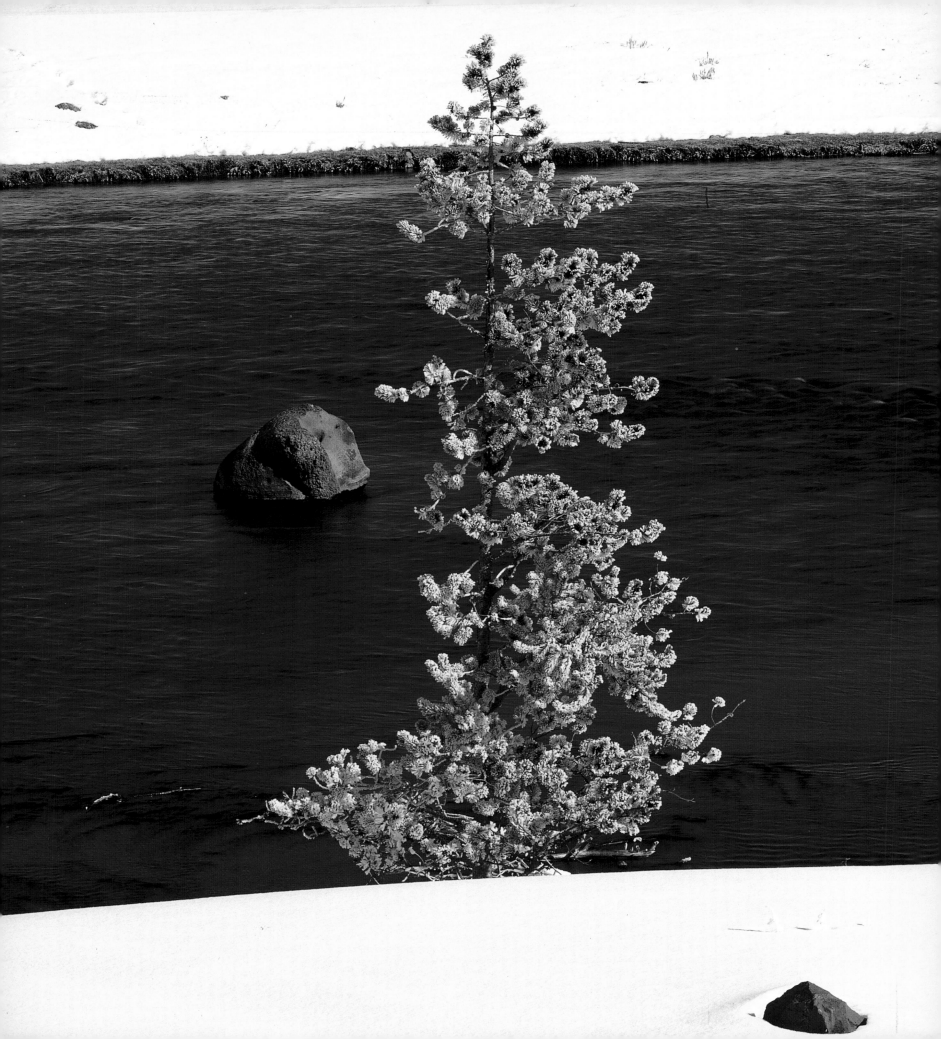

The last snows had not fallen on Yellowstone National Park when I visited at the beginning of May. Pillowing squalls of white danced down through green needles, between stands of charred lodgepole pines. Near Obsidian Cliff, melting snowbanks slid down to a half-frozen creek crowded with ducks and Canada geese, and on Blacktail Ponds, sandhill cranes glided in from southern climes, calling one to the other—karooo, karooo—just as snow swirled down.

In the Hayden Valley, grizzly tracks led to water and back again into thick trees: bears were just waking from a winter's respite in pine-bough-covered dens. I saw one push over a dead log, looking for grubs, while a raven, high in her nest, incubated eggs. At the center of the park, which is the caldera of a dormant volcano, I saw not red lava but white: the frozen surface of Yellowstone Lake. Shaped like a gnarled hand, its three fingers and thumb were fractured plates of ice revolving in a circling wind.

At the end of a warm spring day, shoulders of ice broke apart at Undine Falls, Tower Fall, and Lewis Falls. From the circle of high mountains that rings the park, meltwater flowed in transparent skeins. Those waters joined the Yellowstone River in its long migration north, then east, then northeast, finally mixing with the waters of the Missouri.

The Yellowstone Plateau, made by fire and scraped by ice, floats on a fiery bed. "A paradise of volcanism," one geologist called it. As the first of the country's national parks, Yellowstone is the largest and one of the most

A lone lodgepole pine stands on the bank of the Madison River. The Madison flows through the western entrance to Yellowstone National Park and drops into the steep-walled Madison Canyon, before merging with the Gibbon and Firehole Rivers.

HARSH PARADISE

biologically complex ecosystems remaining in the temperate world.

Suspended halfway between the equator and the North Pole at the 45th parallel, the Greater Yellowstone Ecosystem is the pinched-up, wild corner of three western states. Though the largest part of the ecosystem is in Wyoming, slices of Montana and Idaho are sewn on. The Continental Divide wriggles through its center, and the headwaters of four great rivers—the Yellowstone, the Madison, the Green, and the Snake—have their beginnings here. Down from high mountains, fast-moving streams tumble, some going to the Pacific, some to the Atlantic, crossing high plateaus, incising deep canyons, snaking through broad valleys, pooling in lakes before falling again.

In 1807, a year after being discharged from the Lewis and Clark Expedition, John Colter walked alone across the Teton and Wind River Mountains, crossing through Yellowstone on the way. He is thought to be the first European or American to have set foot there. He was thirty-seven years old. Five years later, and several years after sustaining severe wounds in a war between the Blackfeet and Flatheads, he was dead.

I try to imagine his feelings upon seeing a plume of steam hissing out of the ground in the sudden clearing of a dark forest, or when peering down into the azure pools of a hot spring, the thick brew of a mudpot, or the vastness of the lake.

From the Minnetaree Indians, the name for the river, *Mi Tsi A-sa-zi*, meaning "Rock Yellow River," was later transformed into the French: Roche Jaune, or Pierre Jaune, meaning "Yellow Rock" or "Yellow Stone." The mountain men who followed John Colter—namely, Jim Bridger, Joseph Meek, and Osborne Russell—brought back fantastic descriptions of the fires, steaming vents, vast canyons, waterfalls, and petrified forests. City-dwellers and politicians did not believe such a place could exist and thought the explorers were lying. Newspapers refused to report these stories, and Yellowstone remained relatively unexplored for sixty-four years. By then, John Wesley Powell had already mapped the Colorado River and explored the Grand Canyon, and Thoreau was dead.

In 1869, three adventurers—Folsom, Cook, and Peterson—explored the park. Their findings encouraged Henry Washburn, the Montana Territory's surveyor general, to form an expedition the following year to circumambulate the entire lake on horseback. After hearing the reports from this venture, Dr. Ferdinand Hayden, a geologist with the USGS, began the Hayden Survey of Yellowstone in 1871. In March of the next year, an act of Congress made Yellowstone the first national park.

Little did they know the lasting importance of their act or what a biotic treasure they had preserved. To call the greater Yellowstone area an ecosystem—to call it a system at all—is to trivialize its complexity. An inventory of its 11.7 million acres of geographical, geological, and biological wonders is an embarrassment of riches. What I like to think of as the

Old Faithful is not the largest of Yellowstone's hundreds of geysers, but it is one of the most dependable. Its eruptions spew water and steam 150 feet high, at temperatures reaching 204 degrees Fahrenheit.

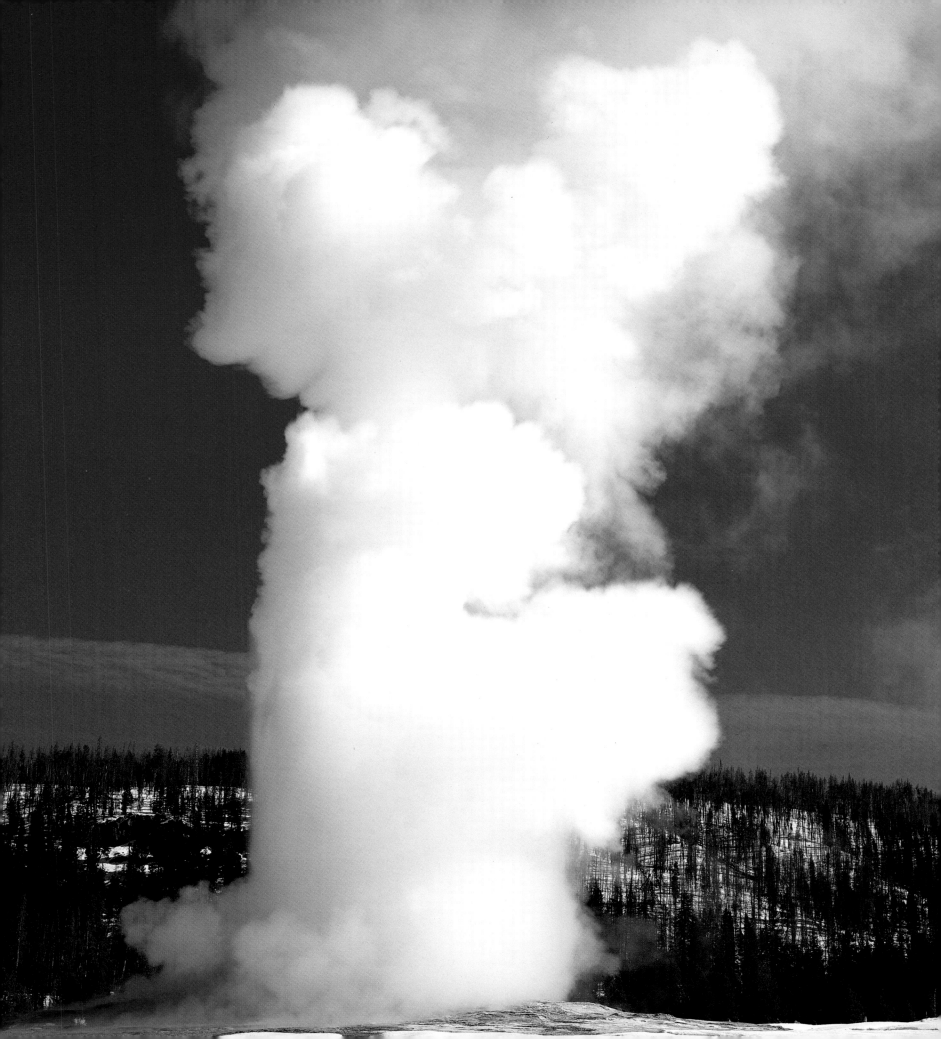

In midsummer, wildflowers—including lupine, yarrow, yampa, blue penstemon, valerian, cinquefoil, bitterbrush, and serviceberry—abound in this meadow near Tower Junction.

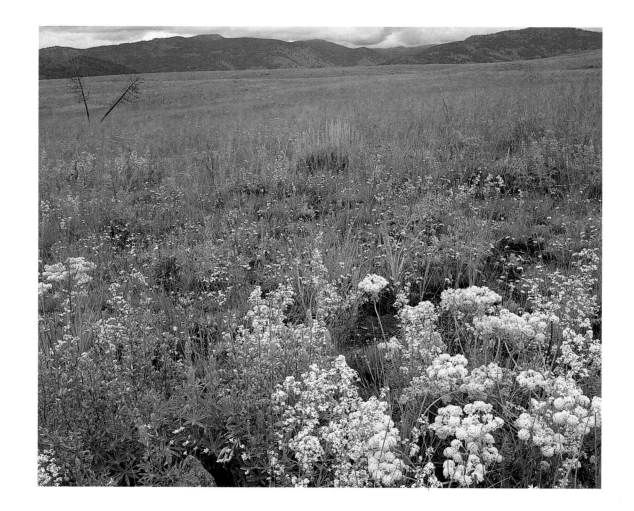

province of Yellowstone, the vast area known as the Greater Yellowstone Ecosystem, is comprised of the park's 2.2 million acres plus its surrounding mountains, forests, and valleys— approximately 18 million acres in all. The area includes two national parks, six national forests, Bureau of Land Management and state lands, wildlife refuges, six interleafing plateaus, a grand canyon, a twenty-mile-long lake, plus dozens of smaller ponds. Yellowstone has ten thousand thermal features, including geysers, hot pools, mudpots, and fumaroles. There are dozens of rivers and creeks, several mountain ranges and eleven-thousand-foot peaks rising above huge glaciated valleys, plus a wealth and variety of large and small animals, birds, insects, and fish.

The Yellowstone Plateau is the remains of many volcanic eruptions that began two million years ago. The last eruption occurred around six hundred thousand years ago. Yellowstone Lake fills part of the volcanic caldera, which stretches forty-seven miles across from rim to rim.

When I visited in May, huge sheafs of lake ice melted in booming reports. Bison slogged through boggy ground, grazing barely visible green. Here and there, the winter-killed carcasses of elk provided food for ravens, raptors, and coyotes. In the Norris Basin, I watched a geyser rise into cumulus clouds, which mixed with the clouds bringing down spring rain. Standing in the midst of hot pots, wild gorges, and whitecapped mountains, it seemed that heaven, earth, and hell were all here in this one place, bound by the vertical stitchery of rain, snow, fire, and steam.

Fire and ice, ash and ice. The mountains, valleys, and rivers of Yellowstone as we know it were built mainly by volcanoes, filled and refilled with ash flows and lava, and covered by tides of ice that each lasted tens of thousands of years. The ice caps were bored through by or collided with hot rock, and the cooling rocks were covered again by ice.

As volcanoes spewed, deep valleys filled with ashy debris, transforming vertiginous terrain into a bald plain with only the hard knobs of mountain tops showing. After the period of cooling began, coniferous forests came into being, then changed into tundra—vast treeless expanses with permanently frozen subsoil. The ice caps that covered Yellowstone melted and grew again at least eleven times. Through the ice, the fiery volcanoes kept erupting until whole mountains collapsed into the caldera and molten, silica-rich, rhyolitic flows spread out like red icing, creating Yellowstone's overlapping plateaus. This enduring play of extremes has created an extraordinary place.

Yellowstone is one of the geologic "hot spots" of the planet. A plume of molten magma, like the fiery torch of a tree, lies only two to three miles under our feet, instead of the usual twenty or twenty-five. An enormous series of volcanic pipes and vents interconnects below ground, allowing steam and hot water to rise to the surface under great pressure. All through the park, these talismans of vulcanism wave their white flags, hissing and belching out of the ground. They let no one forget that—as they wander from Lewis Lake up to Gibbon

Falls, from Ice Lake to Canyon Village, from the Grand Canyon of the Yellowstone to Turbid Lake, from the waters of Yellowstone Lake through Flat Mountain Arm, back to Lewis Falls again—they are cradled in the arms of a caldera which is only resting for the moment, but is in no way dead.

When Yellowstone blew six hundred thousand years ago, one thousand cubic kilometers of lava and ash—twelve hundred times the debris released by Mount St. Helens—drifted east across Wyoming, all the way into Nebraska. An earlier eruption threw a cloud of ash so thick it is thought to have brought on an ice age. Geologists who keep an eye on Yellowstone's calderas say they're inflating and deflating. This seismic activity might indicate a volcano poised to explode. Of course, in the geological timeclock, "poised" could mean an hour or ten thousand years from now. Who knows?

To live with such uncertainty brings on thoughts of the imminence of death and the emanation of living. If the volcano blew, the mountains, wilderness areas, and ranches we love would be ash piles. All trees and vegetation, all human and animal life would be destroyed. To live at the volcano's edge, and to swim, run, and sleep in the arms of the caldera, is to be alive.

I began visiting Yellowstone National Park after moving to Wyoming in the winter of 1975. Knowing that such a vast tract of wilderness was nearby had a calming effect on me. Poring over maps, I erased all human-made boundaries. With my finger, I traced the rim of the caldera, the deep river valleys cut into hardened ash flows, the tormented pitch of mountain ranges. I followed the lines of lodgepole pine forests, the 150-foot-high spewing geysers, the ash flows and carpets of wildflowers.

My eyes wandered over the maps the way the animals wander, down from the high plateaus into deep river valleys, from the source of the Yellowstone River to its wide, smooth ride through the Hayden Valley. They traveled from the terraced hell of Mammoth down into the Paradise Valley, from Two Ocean Plateau and the Pitchstone Plateau down into thickening pine forests. They crossed the Continental Divide back and forth, slipping toward the Atlantic, then the Pacific, down toward the towns of Cody, Gardiner, West Yellowstone, and Jackson. From studying those maps I learned to read the land.

An ecosystem implies the interconnectedness of what lies within its domain, wholes within wholes. The lives and habitats of trout, grizzlies, falcons, voles, ants, bees, and elk are interwoven with those of grasses, wildflowers, trees, shrubs, rivers, mountains, and microorganisms. All depend on microclimates, as well as minerals, water, and energy cycles, to keep them going.

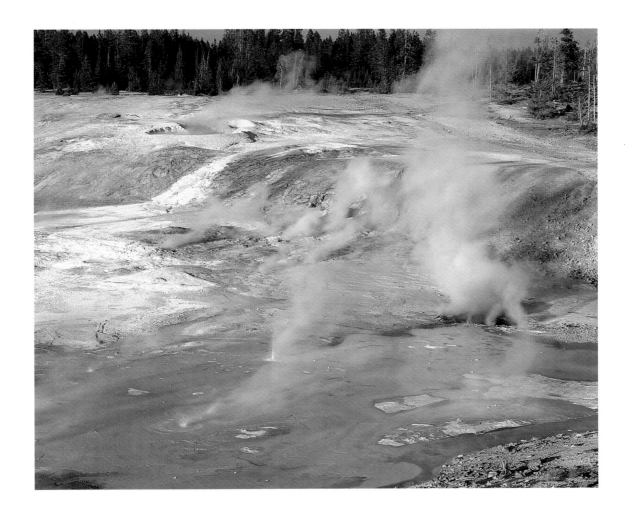

*F*umaroles, like this one in Porcelain Basin, are volcanic vents that steam continuously.

GLACIAL ACTION

During the Pinedale glaciation, an Ice Age which ended thirteen thousand years ago, Yellowstone was covered by a composite ice cap—the aggregate of smaller sheets of ice located in the Absaroka, Gallatin, and Beartooth Mountains and on the high plateaus of the park. This ice sheet was an average of twenty-one hundred feet thick and covered most of what we know as the park today, with extensions north into Montana's Paradise Valley. It reached its maximum size about thirty thousand years ago and lasted seventeen thousand years.

Like most glaciers, the ice cap that covered Yellowstone helped shape the land. It gouged out valleys into steep-walled glacial troughs, carved walls and scraped them smooth, and carried rocks of all sizes on its back, leaving behind long ridges of sediment and huge granite boulders as it melted.

T*he Firehole River is named for the many fumaroles and other hydrothermal features along its course.*

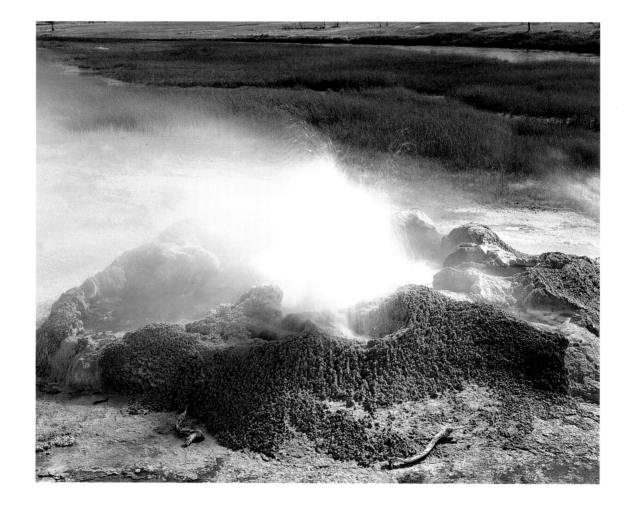

T*he Grand Prismatic Spring of Midway Geyser Basin looks like a river of gold, though it is algae and iron oxide that tint the water.*

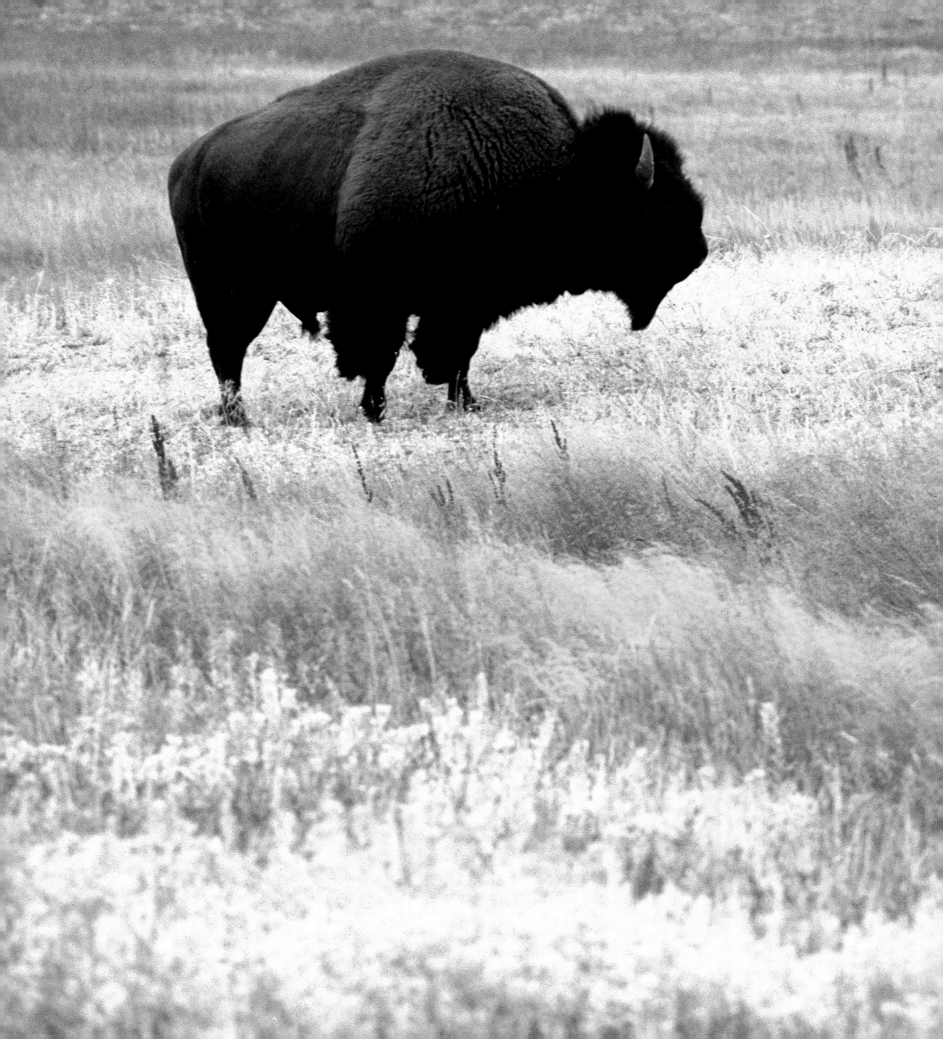

When Yellowstone National Park was created in 1872, the word "ecosystem" was not yet in use. America was still thought to be a vast frontier with land to spare. In the American mind, "land to spare" implied land to be used up in every imaginable way, since there would always be more. It was fortuitous that early Euro-American visitors to the area understood that there was no place in the world like Yellowstone.

When those first visitors arrived, the Yellowstone ecosystem was inhabited by a small band of Native Americans related to the Shoshones and Bannocks. They were later dubbed "Sheepeaters" because they hunted Rocky Mountain bighorn sheep and made bows from their horns. With no horses or dogs, they did not travel great distances. They lived in domed willow houses, storing food in rush baskets and stone basins. Little else is known of their culture.

Native Americans had traveled through and hunted in the park for at least ten or eleven thousand years. They followed the Yellowstone River from the north onto the Yellowstone Plateau, where they picked berries and gathered roots and fibers. Making use of Yellowstone's sources of obsidian rock, they fashioned projectile points with which they hunted bison. Except for the Sheepeaters, when winter came, they moved to the valleys below.

After the reintroduction of the horse to the American continent in the 1700s, the lives of Native Americans changed forever. Once mounted, they adopted a nomadic life, covering hundreds of miles in one season. This brought them into land-use conflicts with other tribal groups. In the vicinity of the park, the Crows lived to the northeast, the Blackfeet to the north, and the Shoshone in the west and south. All hungry for buffalo and in need of a winter's supply of meat, they often shared hunting grounds on the Yellowstone Plateau, which they came to view as neutral territory.

The early years of the park were full of other problems, too. The extermination of wolves and other predators was already in full force, supported by Wyoming's governor, who said: "Every civilized country has recognized the necessity of state aid in the extermination of predatory wild animals." More state money was spent on killing wolves and coyotes than for support of the university.

The development of a land ethic takes a long time. It is an ideal difficult for humans to embrace because it assumes an equality among all living beings and all elements in the natural world. There was a vast chasm between nineteenth-century ideas of civilization— like those of Descartes—and the biologically driven, more accommodating ones of wilderness and wildness. While we made heroes of the mountain men who tramped across the Yellowstone Plateau, we were also hellbent on civilizing the very places whose wild beauty their lives and writings celebrated.

Many proposals for uses of the park were offered. The one that recommended turning Yellowstone Lake into a reclamation reservoir failed, as did the request to allow twenty-five thousand head of cattle to graze there. One hundred twenty-two years after the

Buffalo graze in the lush, secluded meadows of the Lamar River Valley.

founding of the park, our ethics regarding land use are still conflicted. The guiding light has been, and will continue to be, an understanding of Yellowstone as a biological province. As one environmental lawyer and writer told me, we must learn to think like an ecosystem.

Even as early as 1885, a congressional committee working to make the Yellowstone area a national park said: "The park should, so far as possible, be spared the vandalism of improvement." It is better understood today that management policies must be made biologically, not politically.

One hundred years later, the park's head naturalist told me that the park must be managed within a regional context. The problem is that from the beginning, the park's boundaries were not drawn ecologically, but politically. Animals don't understand this very well. The northern boundary of the park cuts right through the bison's winter range, and the religious community that owns much of the valley below is growing truck gardens—what the Park biologists refer to as "salad bars for grizzlies." Park officials lament the fact that the public only owns "half the pasture."

When wilderness boundaries are made without regard to ecosystem integrity, what results is a string of island habitats, ever more separated from other islands of wild land. Public enjoyment and preservation are ultimately at odds because the combination results in an ecosystem out of balance. Humans are too plentiful, and wolves, bears, elk, bison, martens, muskrats, wolverines, mountain lions, bobcats, antelope, river otters, bighorn sheep, peregrine falcons, passerines, raptors, and native trout—among many other species—are not plentiful enough.

"We have to stop interfering. We have to stop thinking we know best. The answers are in nature. It tries to tell us what it needs to survive but we don't take the time to look or listen. The willingness to change has to come from in here," the park naturalist told me, thumping his heart.

I returned to Blacktail Pond, where I have sat many times over the years. I like to go back to the same place repeatedly, so I can see how a semblance of order and sameness irrupts into patterns of chaos and change. How mutualism and relatedness tie everything together like a string of pearls: a cloud, a crane, a bear, a pond, a human, a muskrat, a trout, an aspen grove, a forest, a volcano, a stone. All are gathered on the same string, each one beautiful, each one separate and related, each one necessary and vital to the existence of the others.

Later I climbed Mount Washburn. From that 10,243-foot vista in the north-central part of the park, I could see a mosaic of melting snow and new grass, of green pines and the black staves of burned trees. I saw how beautiful it was—not postcard beauty, but the natural world, unadorned, untampered with.

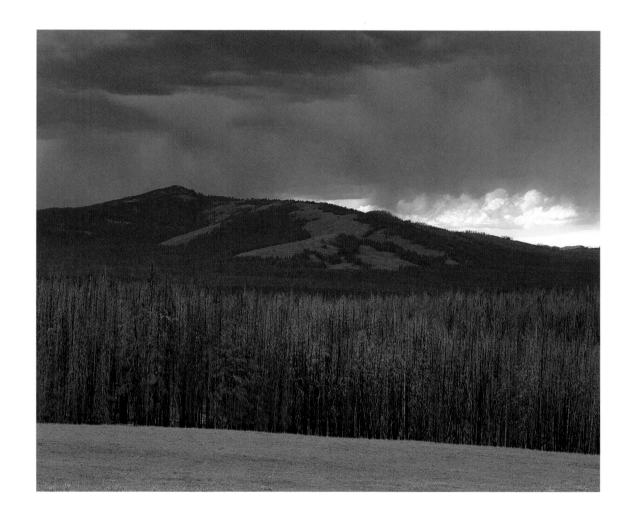

The fires of 1988
burned the tight canopy
of lodgepole pines at
Dunraven Pass, letting
in water and sunlight
and allowing pine
seedlings, grasses, and
wildflowers to flourish.

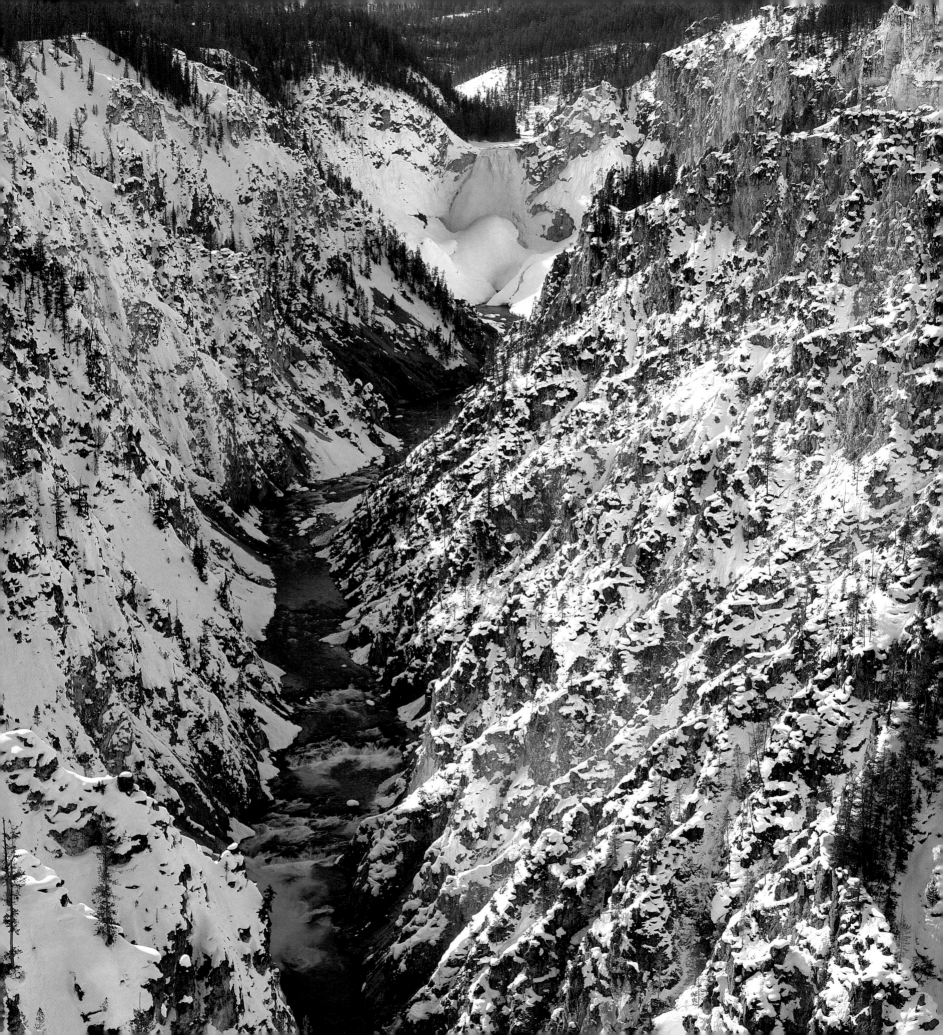

Three billion years ago—before the Yellowstone Plateau existed, before there were mountains and lakes—small continents of land moved about, colliding into each other, and mountains shot up from the impacts. Life was just beginning to stir, and single-celled organisms took form. After several bursts of collision-induced mountain building, two billion years of quiet ensued.

North America was then located where Ecuador exists today, and the climate was tropical. Half a billion years ago, the continent began its slow trip north to reach its present latitude. The area now known as Yellowstone rode on its northeastern edge. Shallow tropical seas and tidal flats extended for hundreds of miles, washing against and around Wyoming, extending all the way from eastern Idaho to South Dakota. Single-celled organisms gave way to creatures bearing shells and carrying bones: trilobites, crinoids, and jawless fish. Seaweeds—the first plants—took purchase on mud flats, their holdfasts evolving into water-imbibing roots. In response, animals evolved with teeth and digestive systems so they could feed on the vegetation.

During this northward passage, the eastern edge of North America ran into Europe. As continental edges crumpled, the Appalachian Mountains grew, welding the two continents together. The shock of this collision 320 million years ago rippled through North America, causing

FLOODS OF FIRE, TIDES OF ICE

small mountains—the ancestral Rockies—to grow in what is now Colorado and southern Wyoming. During these years, fish became amphibians, and the climate dried.

Later, the tectonic plates reversed their direction, and North America split apart from Europe in a westward journey that continues today. That rift enlarged the embryonic Atlantic Ocean and engulfed the floor of an already very old Pacific Ocean, tearing islands and microcontinents loose. Whenever one of these exotic terrains—small islands and microcontinents—bumped into North America, a mountain range arose and later eroded, adding sediment to the bordering seas.

What we now know as Yellowstone was no longer at the edge of the continent but was part of a Mediterranean-like sea, trapped between young, growing mountains on the west and ancient, low-lying land on the east. Long and narrow, the sea extended from British Columbia to Mexico, and from South Dakota to Utah. The continuous erosion of young mountains caused sands and muds to be dumped into its waters in prodigious quantities, eventually filling in the sea, which disappeared entirely some 175 million years ago. Evidence of these deposits is visible today: the shales that make up Mount Everts near Mammoth Hot Springs in Yellowstone are ten thousand feet deep. Dinosaurs roamed these lands, and their bony skeletons and egg nests are still found.

Sixty-five million years ago, continental collisions began again. This time they rippled from west to east, causing large slabs of North American crust to form the mountains of western Wyoming. Squeezed violently, the continent buckled and broke, causing huge blocks of rock to thrust up or down as if on an elevator. The upward blocks formed the Gallatin, Teton, Targhee, and Beartooth Mountains of Yellowstone.

Early in this mountain-building phase, called the Laramide Orogeny—which lasted more than ten million years—a large meteor hit earth. Dust filled the skies, blocking out the sun, and temperatures fell. Vegetation died, as did the dinosaurs. As the climate moderated, conifers, grasses, and flowering plants thrived, and mammals began to populate the land.

Forty-nine million years ago, a last gasp of plate collision resulted in a chain of volcanoes that grew in a line from Missoula, Montana, to Dubois, Wyoming. For at least three million years, they exploded violently, depositing ten thousand feet of ash and debris in the valleys and burying the slightly older mountains. The Absaroka Range, on the eastern edge of Yellowstone, is the remains of those ash falls and debris flows. The petrified trees on Specimen Ridge are what's left of an ancient forest that was buried alive. Mount Washburn, which overlooks the Grand Canyon of the Yellowstone, is the preserved remains of one of those volcanoes.

For tens of millions of years after, Yellowstone was quiet. The shallow seas dried. The reshaping of the mountains of Yellowstone began as the ashes that had been laid down by volcanoes began to erode from centuries of rain, snow, and wind.

Sixteen million years ago, at the junction of Oregon, Idaho, and Nevada,

The steep-cliffed amphitheaters of Pilot Peak and Index Peak, in the Beartooth Mountains, were carved by glaciers.

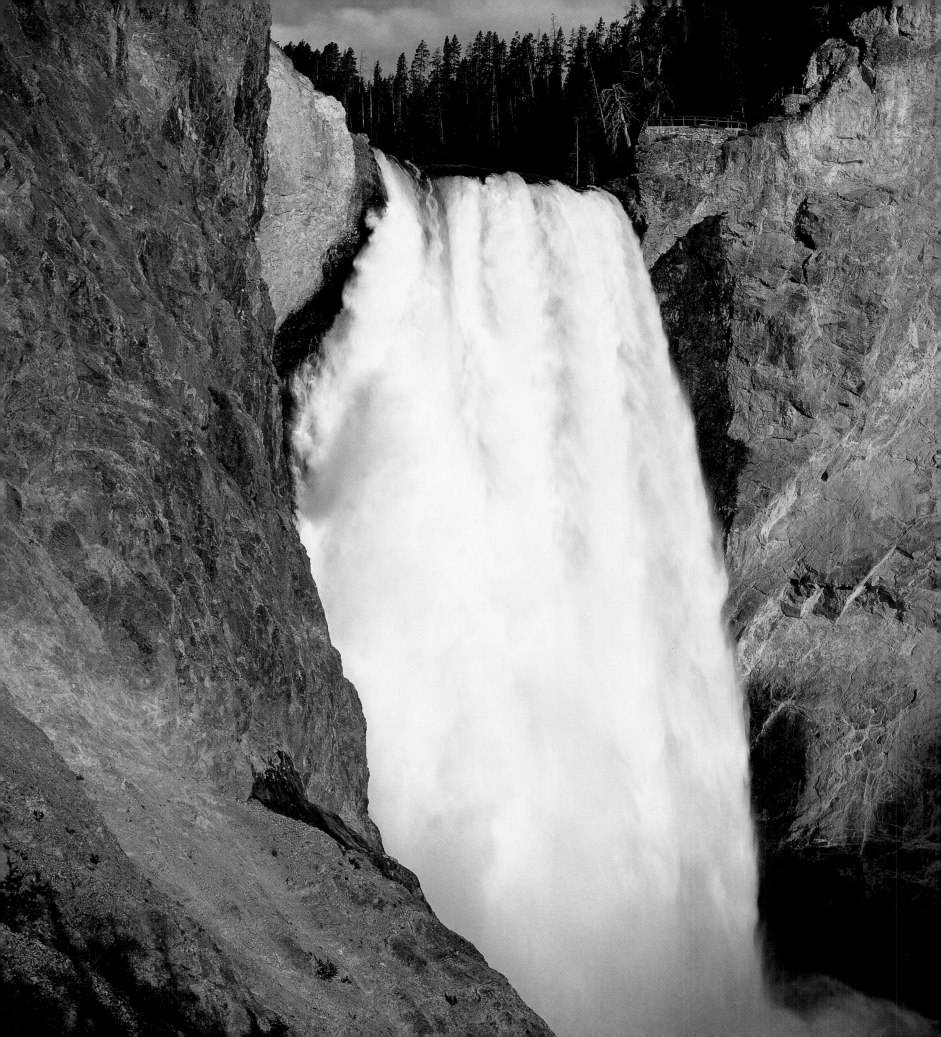

a cylinder of hot material from the earth's deep mantle pushed upward into the base of the planet's crust. As a result, a series of eruptions occurred that changed the shape of the northern Rocky Mountain states and began the shaping of Yellowstone National Park as we know it today. A series of explosion pits opened up, created by volcanic eruptions so violent that they literally blasted holes in the earth's crust. Hot gases spewed from circular fractures around the caldera margins, carrying melted rhyolitic crustal material—molten glass—that settled far out from the caldera, once again filling valleys, burying the old landscape to create one anew. Later, as surface rocks sank into the caldera—the center of the volcano—lava flows filled it, then spilled out as low plateaus. These are the high benchlands that form the park.

Fourteen million years later, another chain of seven explosion pits erupted across southern Idaho and ended in Yellowstone National Park. It was as if a hot torch had been held underground and had burned through the skin of the planet.

Though it's easier to imagine the hot torch moving, in reality the continent was moving over the torch. Shifting plates cause North America to move 2.5 inches a year to the southwest. As a result, the hot spot burn is moving 2.5 inches to the northeast each year. As the Yellowstone area moved over the hot spot two million years ago, the southwestern caldera rim near the town of West Yellowstone came alive with volcanic activity. The obsidian cliffs, hot springs, and geyser basins, as well as Old Faithful, are evidence of that heat.

The mantle plume heats the area surrounding the burned crust, causing it to expand and form a broad dome, two hundred miles wide and half a mile high. The slowly moving dome resembles the bow wave of a boat, activating faults and causing land around it to rise, then fall, as it passes through. The progress of one such bow wave has caused two historic earthquakes: the 1959 Hebgen Lake earthquake and the Borah Peak quake in 1983.

The last three cycles of volcanism to shape the park occurred 2.2 million years ago at Huckleberry Ridge, 1.2 million years ago at Mesa Falls, and six hundred thousand years ago at Lava Creek. Each pyroclastic flow produced an outpouring of swiftly moving ash called "welded tuff." The quantity of ash was mind-boggling: at Huckleberry Ridge, for example, six hundred cubic miles of tuff poured out, as compared with the tiny expenditure of Mount St. Helens, which gave out a half cubic mile of debris. The ashes from these calderas have been found as far away as Indiana.

As the magma chamber underneath the park emptied, its unsupported roof collapsed. In turn, the sinking roof was swallowed by new rising magma and spewed back out— a flow that spread far and wide, filling in the valleys. The resulting plateaus are now known in Yellowstone as the Central Plateau, which includes the Hayden Valley, the Solfatara Plateau around Mount Washburn, and the Mirror, Pitchstone, and Madison Plateaus.

Is the caldera of Yellowstone National Park ready to explode again? Perhaps. Geologists have identified two domes rising above the magma plume: Mallard Lake Dome, near

During high water in June, 64,000 gallons of water per second tumble over Lower Falls.

FOLLOWING PAGES:

In the 1800s, explorers reported hearing Roaring Mountain "roar," but today it merely rumbles and hisses. The sounds are produced by steam and gas escaping from boiling water just below the surface. The mountain is scarred by the remains of charred trees left by the 1988 fires.

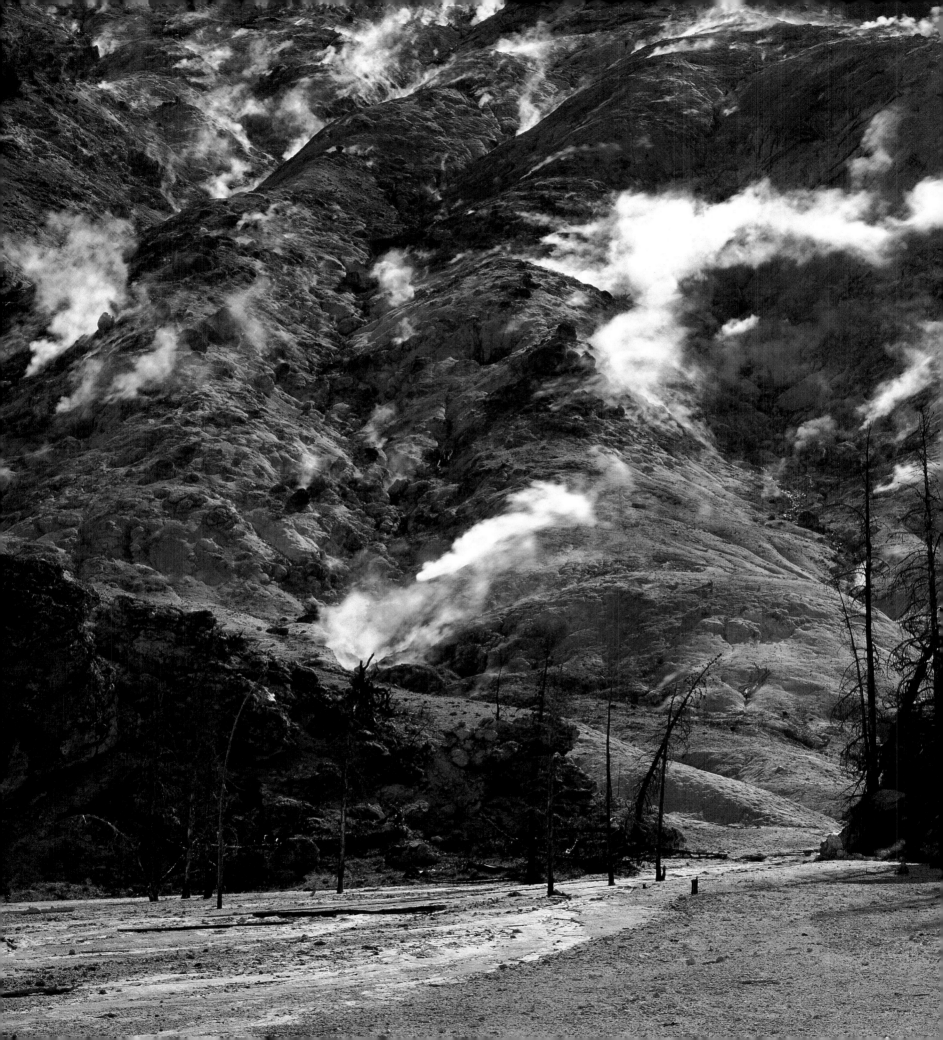

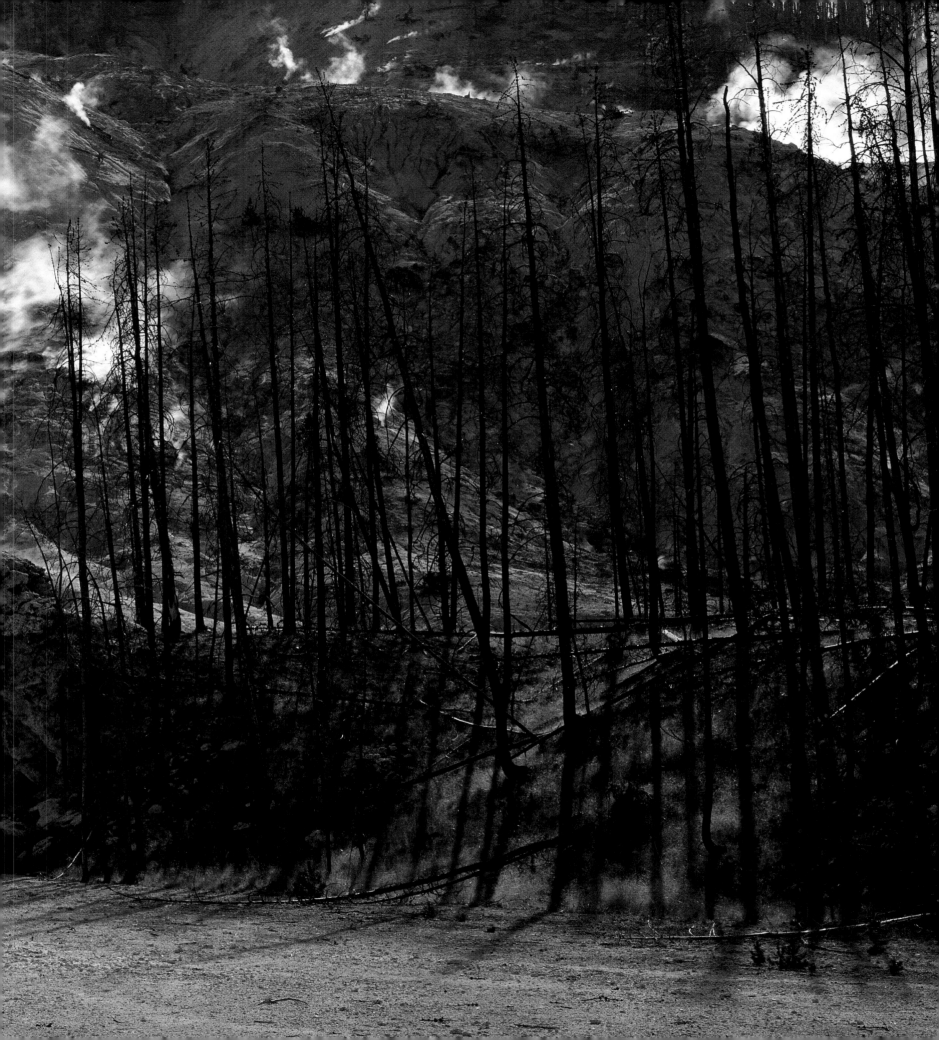

Old Faithful, and the Sour Creek Dome near Canyon. As the plumes burn upward, "drops" of molten crustal material—rhyolite—rise. One of these "drops" is rising beneath Sour Creek Dome and is now only two miles below the surface. As it inches upward, a major Yellowstone explosion could be near—though "near" might mean five thousand years from today.

In Yellowstone National Park, there are roughly two thousand hot springs and two hundred geysers. Because of the molten magma chamber just beneath the ground, the heat escaping from a square inch of Yellowstone soil is thirty times greater on average than that flowing from a square inch of land anywhere else in the world. The heat from water rising to the park's surface is estimated to be 771 million kilocalories per second— enough to melt three tons of ice per second.

Hot springs and geysers come into being when rainwater soaks down through fractures and faults to the hot rock wedged above the magma. Hot springs bubble up where the heated water flows to the surface and escapes. Geysers arise when the hot water is obstructed and rises back up under enormous pressure.

The plumbing necessary for a geyser comes from rock that contains large amounts of silica. At temperatures above 180 degrees Fahrenheit, silica dissolves and precipitates out along the margins of the fracture site to form a thick sinter coating resembling opal. It is through these sinter-lined pipes that geysers blow.

Geysers are ephemeral. They are wiped out by steam explosions that send siliceous rocks skyward, or by earthquakes that crack the pipes, letting steam escape. Earthquakes can also cause geysers. A temblor can seal an open fracture and create other passages, leading to the formation of new pipes through which steam can escape. After the 1959 Hebgen Lake earthquake, 289 springs in the Firehole Basin—including 160 hot springs— erupted as newborn geysers.

Fire and ice. Those were the final shaping elements of the park. Three million years ago the world began to cool. Winter snows that did not melt by the end of summer congealed into glaciers, which later merged together into whole ice sheets—mountains of ice such as the one that covers most of Greenland. Two million years ago, coniferous forests came into being, changing into tundra as temperatures chilled. Large mammals such as horses, cattle, mammoths, camels, and tigers thrived. Later, humans began to move in fits and starts from central Asia across ice and land bridges into Alaska and down the Pacific Coast all the way to Tierra del Fuego. Slowly, new populations found niches in the Americas.

Ice sheets advanced, then retreated during warming interglacial periods, such as the warm, relatively iceless era we're living in now. Glaciers coalesced or moved down, covering large parts of the North American continent. Four times the continental ice sheets retreated. Every hundred thousand years, smaller, localized ice ages occurred. Each time, a part of Yellowstone was covered with ice sheets. The last small ice age, known as the Pinedale Advance,

THE GRAND CANYON OF THE YELLOWSTONE

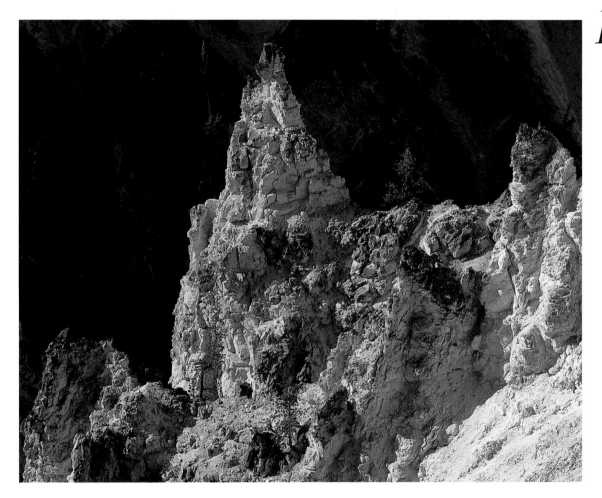

More than twenty miles long and one thousand to fifteen hundred feet deep, the Grand Canyon of the Yellowstone was created by the carving power of the Yellowstone River. The river cut down through deep layers of rhyolitic rock that had been softened by volcanically heated water. Exposed iron oxides contained in the rhyolite give the canyon walls their yellow and orange hues. The erosive action of the water also created breathtakingly beautiful cataracts, such as the Brink of the Upper Falls, the Upper Falls, and the Lower Falls.

Artist's Paint Pots, burbling mudpots east of Norris

A fumarole at West Thumb Geyser Basin

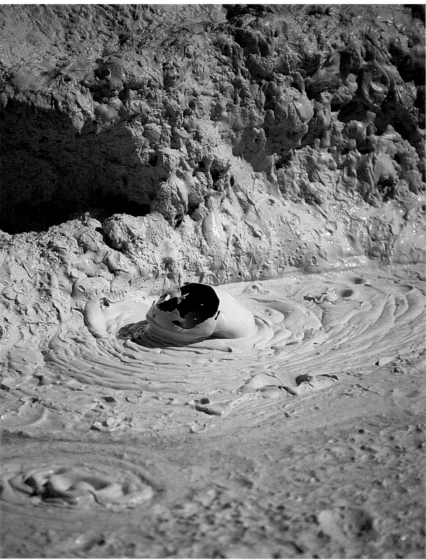

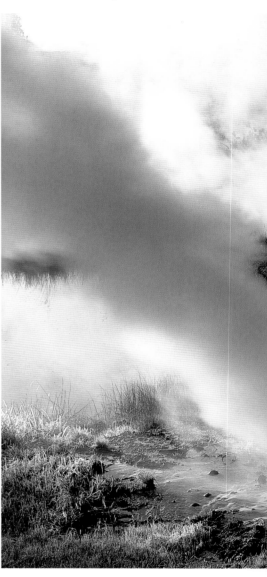

HOT POOLS OR HOT SPRINGS

MUDPOTS

FUMAROLES

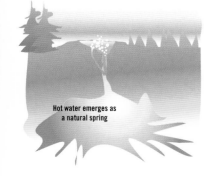

Hot water emerges as
a natural spring

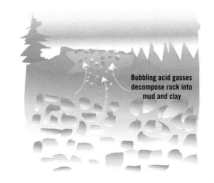

Bubbling acid gasses
decompose rock into
mud and clay

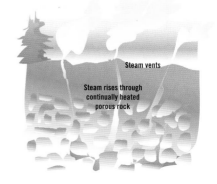

Steam vents

Steam rises through
continually heated
porous rock

Old Faithful Geyser

Morning Glory Pool, a hot pool in the Upper Geyser Basin

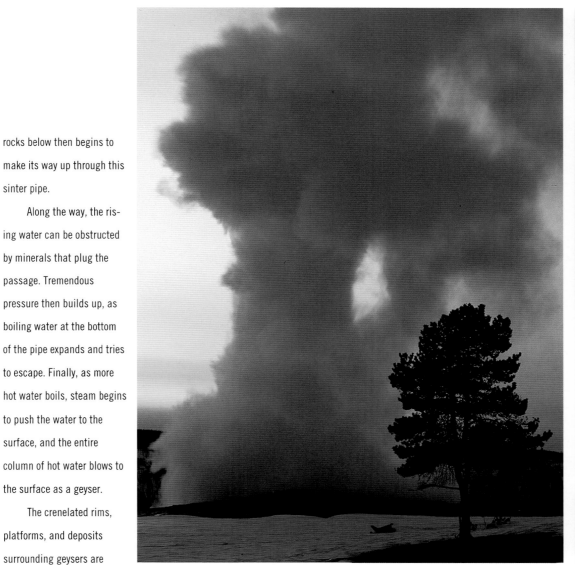

rocks below then begins to make its way up through this sinter pipe.

Along the way, the rising water can be obstructed by minerals that plug the passage. Tremendous pressure then builds up, as boiling water at the bottom of the pipe expands and tries to escape. Finally, as more hot water boils, steam begins to push the water to the surface, and the entire column of hot water blows to the surface as a geyser.

The crenelated rims, platforms, and deposits surrounding geysers are formed when mineral-rich water deposits silica around the perimeter of the geyser hole. The mounded terraces at Mammoth Hot Springs, however, are the result of sedimentary deposits of calcium carbonate. Upwelling hot water dissolves the mineral from surrounding rock. The calcium carbonate spills out, dries, and hardens into a marblelike substance called travertine.

Yellowstone's steaming hot springs form when any kind of precipitation—snow, rain, sleet, or hail—soaks into the ground and works its way down through cracks deep into the earth, where it comes into contact with hot volcanic rock. Because hot water is less dense than cold, it tends to rise. Along the way it may be heated to the boiling point,

GEYSERS

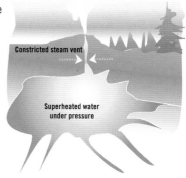

Constricted steam vent

Superheated water
under pressure

GEYSERS, HOT SPRINGS, AND
OTHER GEOTHERMAL FEATURES

Yellowstone National Park's steaming and burbling wonders include some two hundred geysers and thousands of hot springs, mudpots, and fumaroles. All exist because fiery magma from millions of years of volcanism lies a mere two to three miles below the surface of the Yellowstone Plateau.

There are four major geyser basins in the park: the Upper, Middle, and Lower—all clustered around Old Faithful—and, to the north, the Norris Geyser Basin. A fifth of all the world's geysers are located in the square mile around Old Faithful. Despite its fame, however, Old Faithful is not the largest of these aqueous eruptions. Steamboat Geyser, in the Norris Geyser Basin, shoots its column of water more than two hundred feet into the sky, higher than any other known geyser. And then there's Giantess Geyser, a powerful plume of water and steam that erupts only a few times a year. But when Giantess blows, the ground shakes, and water rises up twice an hour for two days.

Geysers form only in places where the surrounding rocks contain large amounts of silica. The silica dissolves when underground temperatures climb above 180 degrees Fahrenheit. The glassy mineral then precipitates along the water's pathway through the earth. A thick, opal-like sinter coating grows, transforming the fracture into a tight, tough pipe. Water that has been heated by hot

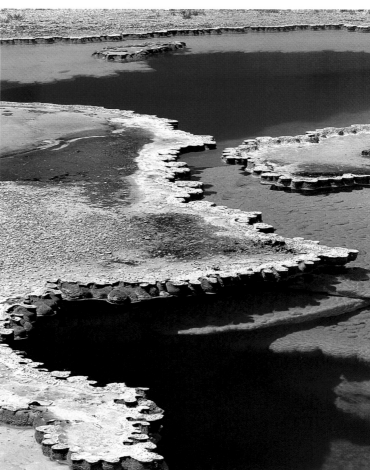

A sinter formation at Doublet Pool in the park's Upper Geyser Basin.

Travertine terraces at Minerva Hot Springs

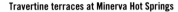

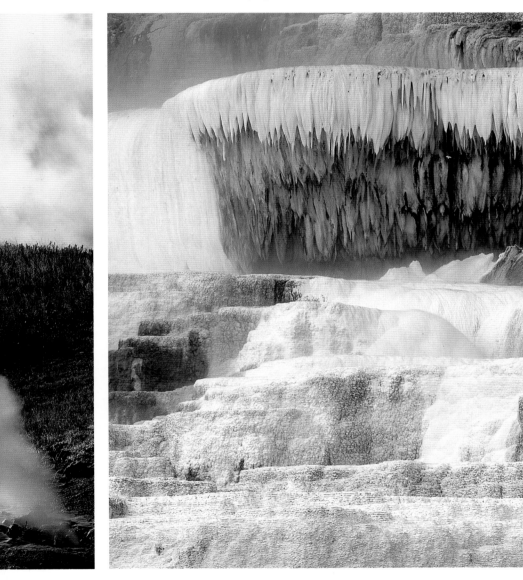

such as Black Dragon Cauldron, are tinted by iron oxide or mineral particles suspended in the bubbling water, as in Sulphur Cauldron.

When clay mixes with hot spring water, mudpots form—belching, burbling, wheezing, hissing, and splatting in their earthen vats. Their paint-box colors come from the mixture of mud with various minerals, gases, algae, and bacteria. Yellow mudpots are mixed with sulfur, and red and pink mudpots are tinged with iron oxide.

Sometimes the water table hits the boiling point, but there is too little water to erupt into a hot spring or geyser. In these cases, a vent may form in the earth's surface through which steam escapes continuously. This perpetually steaming pit is called a fumarole.

causing it to rise rapidly and emerge as a hot spring or hot pool. The bubbling on top of a hot spring, however, is not boiling water, but rather carbon dioxide that is expanding at the surface.

The hot pools of Yellowstone are memorable for their brilliant colors. The waters are variously deep blue, rainbow-colored, pink, azure, emerald, and yellow. The water takes on a deep blue hue when the temperature of the hot pool exceeds 167 degrees Fahrenheit. The super-heated water absorbs the sun's red rays and reflects back only the blue. Other hot pools,

TRAVERTINE TERRACES

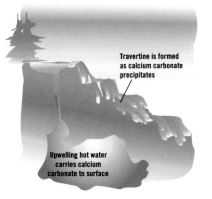

Travertine is formed as calcium carbonate precipitates

Upwelling hot water carries calcium carbonate to surface

reached its peak around twenty-eight thousand years ago, and the ice cap that covered Yellowstone filled mountain valleys with long ribbons of ice that extended out into the basins and plains.

This last Yellowstone ice cap was twenty-one hundred feet thick and covered more than thirty-four hundred square kilometers, including a long northward extension into the Yellowstone Valley. It was a composite of smaller glaciers that had formed in the Absaroka, Beartooth, and Gallatin Mountains and of several ice caps found on the high plateaus in the park. The ice sheet lasted for approximately seventeen thousand years and finally melted thirteen thousand years ago—just after the time that human beings had begun to filter into the Americas from central Asia.

All during these years, tides of ice alternated with tides of fire, and sometimes the two overlapped and met. When ice moved over lava flows, hot rock cooled down into obsidian, which was blasted into tiny particles by steam explosions. Rivers of melting water gushed out, spreading across the plateaus, carrying black glass sand. Now, that smooth, glassy landscape stretches eastward from West Yellowstone to Madison Junction.

When ice moved over preexisting hot springs, the ice melted, funneling surface water down into the spring. The water built up pressure until it blew as steam, creating yet another kind of eruption pit: a hydrothermal crater.

There are at least ten such craters in the park—at Twin Buttes northwest of the Imperial Geyser and along the shores of Yellowstone Lake, including Indian Pond and Turbid Lake. The largest explosion crater is at Mary Bay, a circular depression that is two miles across from Storm Point to Steamboat Point.

The geologic history of Yellowstone National Park is a diary of violence, dynamism, chaos, and change. Not just the gradual change of a two-inch-per-annum uplift, or a million-acre forest fire, or a few pines recapturing a meadow. Layers upon layers of glacial, sedimentary, igneous, and organic deposits tell the ongoing saga of upheaval and assault. Mountain ranges have been lifted, tilted, dropped, then buried in ash. These forms have been eroded, scraped by ice, and covered over with volcanic debris again. It is a place where, if we could live long enough, we would see a landscape transformation so complete we would not recognize anything.

"I'm waiting to see when the next ice sheet will cover us and the next volcano will blow it apart, or if global warming stays with us, when the shallow seas will cover us again," one geologist said in a letter after receiving my postcard from Yellowstone.

"Maybe Yellowstone is like the face of a very old person who does not die," my friend continued. "The ruination of the face keeps going on and on until it has become something else completely … that's how it has been in Yellowstone and will always be."

Even the earliest explorers had an inkling that Yellowstone is a place whose beauty derives from wild cycles of creation and destruction. In the 1800s, one early explorer of Yellowstone wrote: "We are now far into the interior and going deeper. We know not what perils threaten us or what beauty lies ahead. But we are prepared for anything and we would not turn back if we could."

The Firehole River in the western part of Yellowstone National Park flows through geological hot spots before it merges with the Madison River. Because molten magma is just below the surface in this part of the park, the water of the Firehole River runs warm, and steam bubbles to the surface of Firehole Lake.

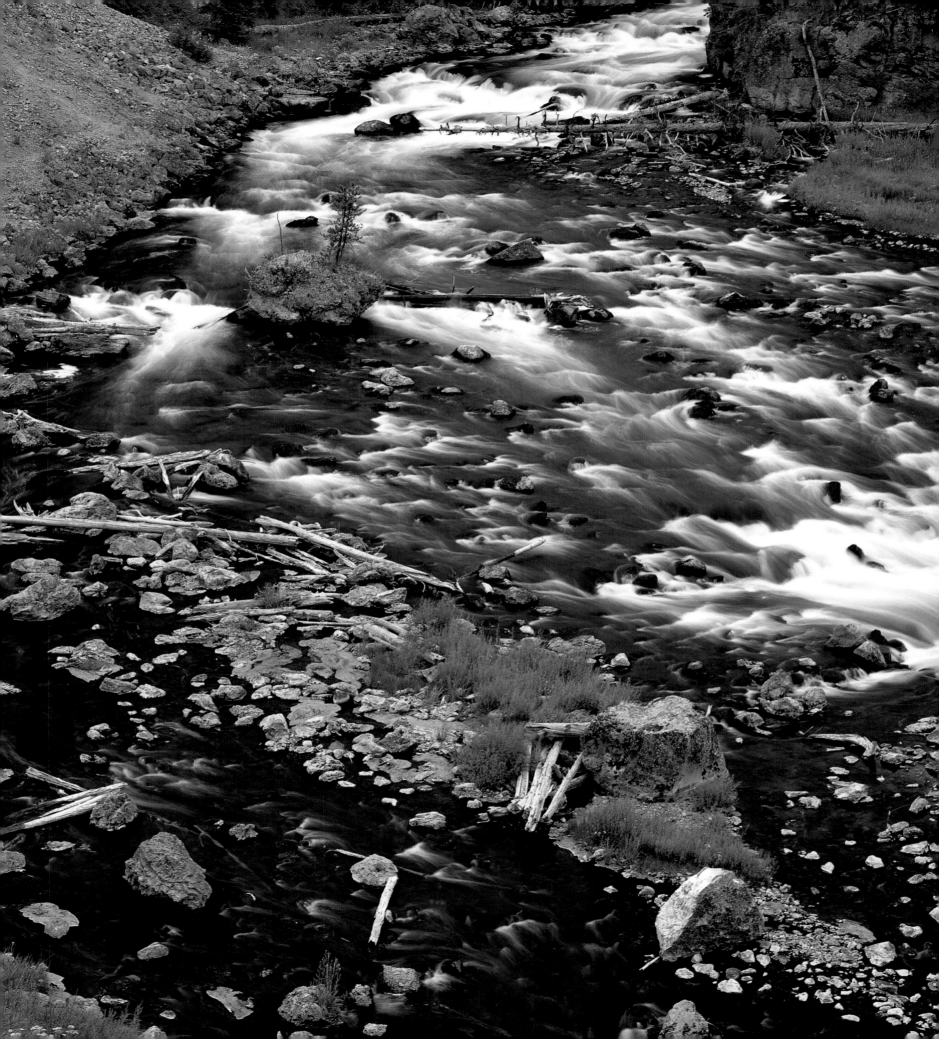

Basalt is a fine-grained, volcanic rock which is high in iron content. Molten basalt flows rapidly in thin streams to form widely spreading sheets of lava. As it cools, the basalt crystallizes and may contract into rock columns, like those seen at Yellowstone's Sheepeater Cliffs.

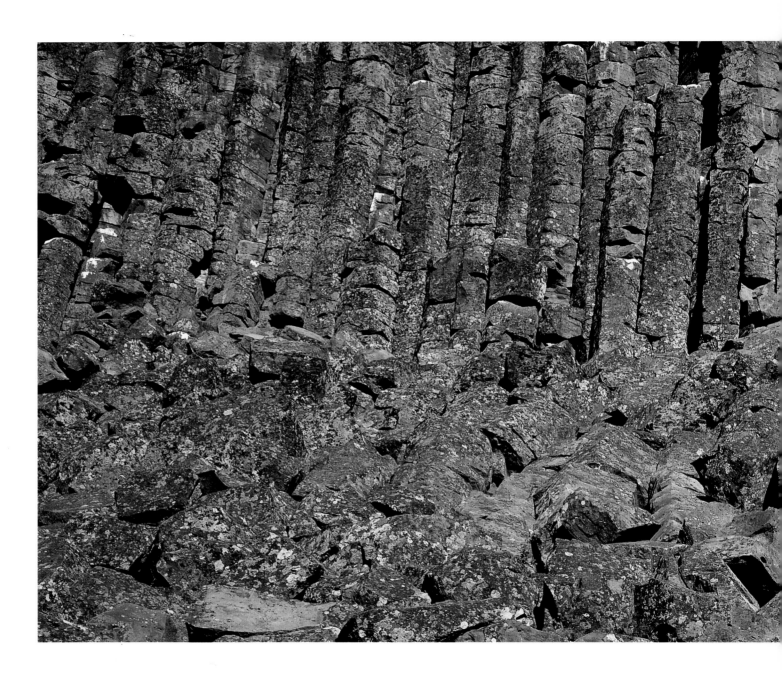

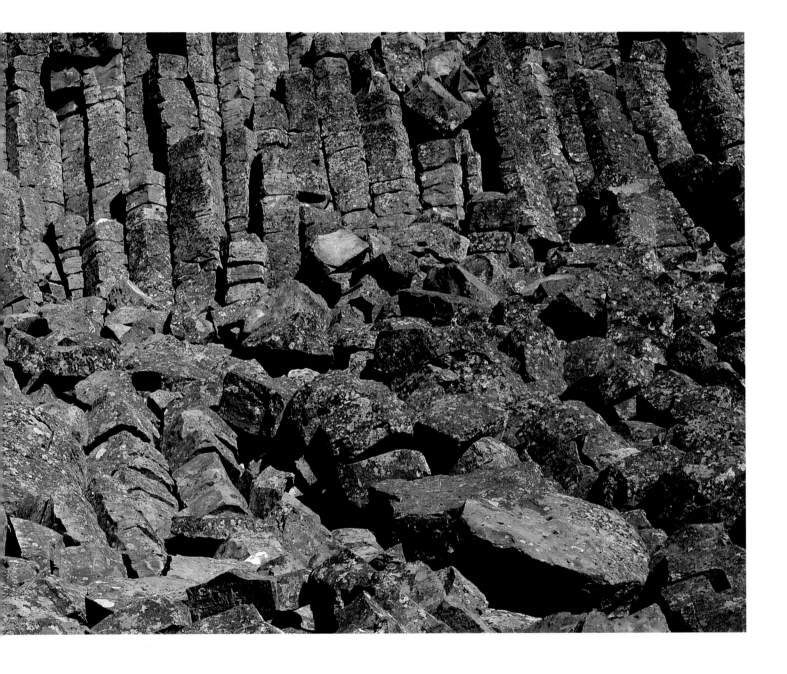

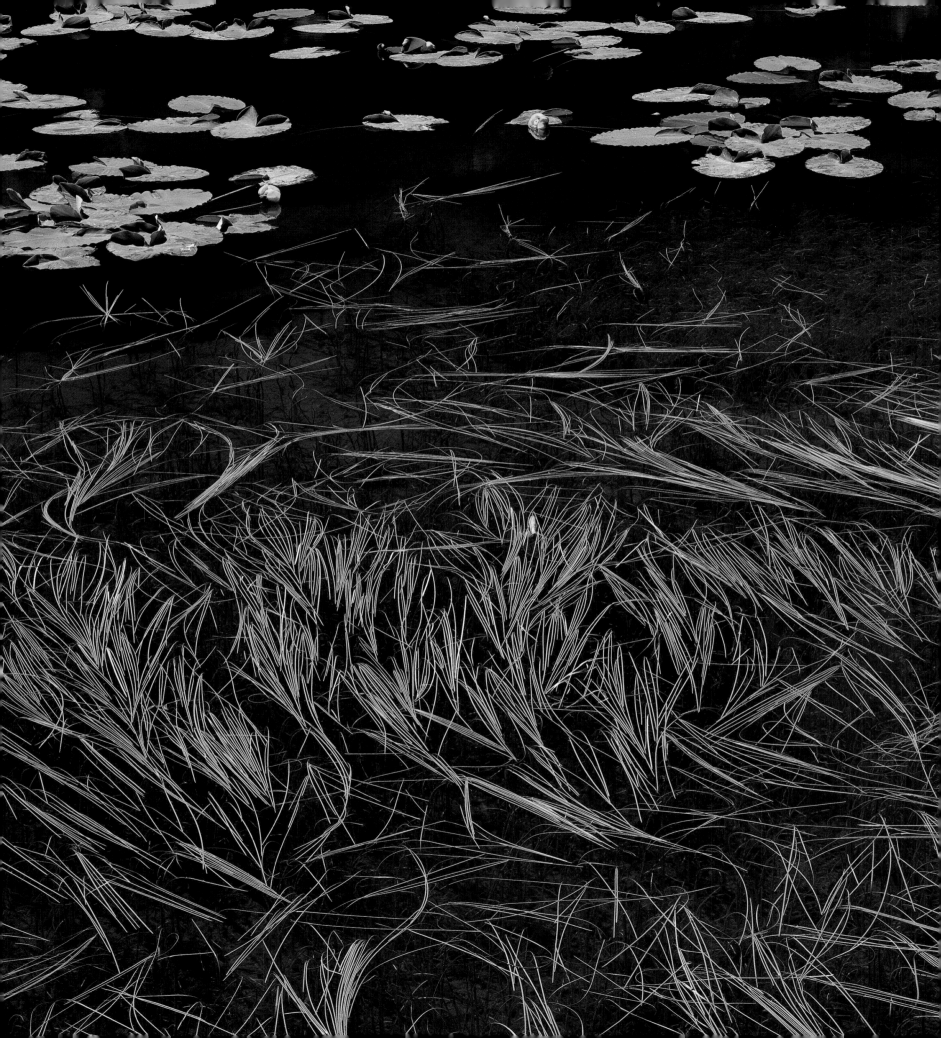

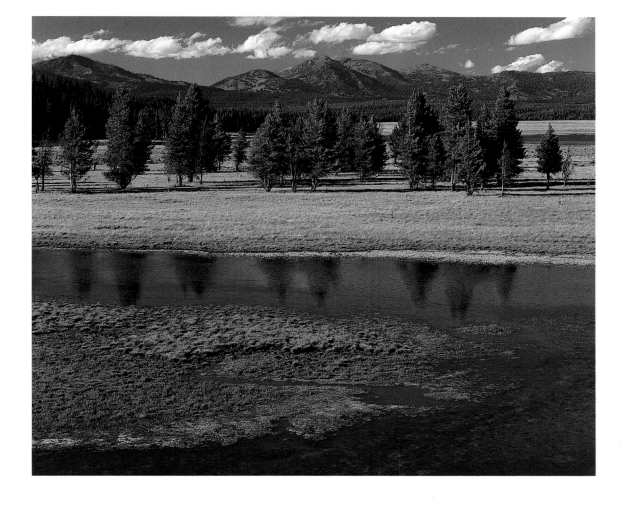

Grasses and
Indian pond lilies float
atop Isa Lake.

The Yellowstone
River meanders through
the Hayden Valley.

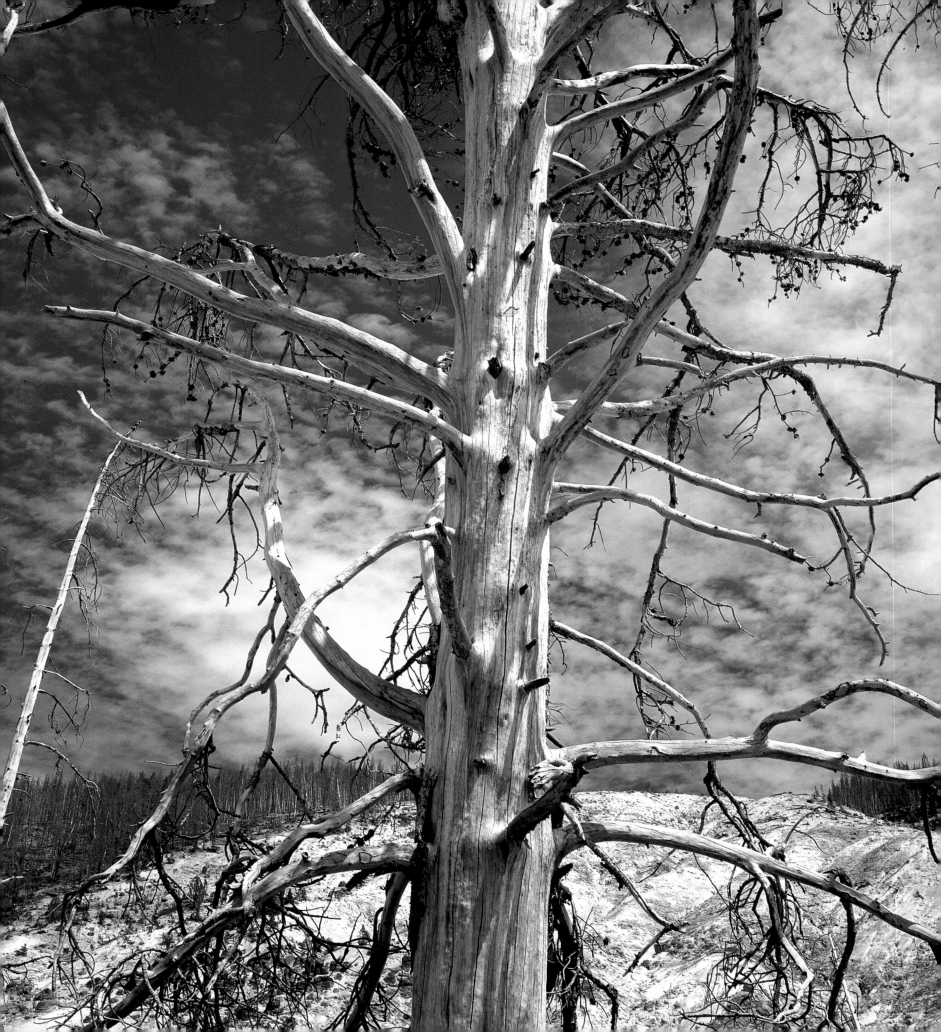

When I visit Yellowstone National Park, I try to remember that all its vegetation has been wiped out by volcanism and had to begin over again in a regenesis, that seeds migrated from vast distances on wind and on the backs of newly migrating animals to colonize the ash- and lava-covered ground.

In mid-May I drove through the east gate. Up from the valley floor to Sylvan Pass, I passed through crumbling walls of snow that funneled down to the shores of Yellowstone Lake. The lake was white, an icy eye. Its edge is part of the rim of an ancient caldera. Fire underground, and above, ice. Pulling off the narrow road to watch bison graze, I looked at a map of the park in elevation and saw how the volcano blew, where lava spread to form the wide plateaus, how the fortress-like mountains that ring it are in part the walls of the caldera that once held fire.

Cradled in this volcanic eden is the flora of Yellowstone, a species list of flowers, grasses, forbs, shrubs, and trees that is wonderful to read. There's sickletop lousewort, Richardson's needlegrass, Idaho fescue, rosy pussytoes, heartleaf arnica, sticky geranium, bearded wheatgrass, arctic willow, yellow spike-rush, trapper's tea, cinquefoil, junegrass, more than fifty kinds of sedge, big sagebrush, fringed sagebrush, and silver sage, Nuttail's alkali-grass, limber pine, lodgepole pine, and whitebark pine, as well as pinegrass, prairie smoke, and poverty danthonia—just to name a few.

We look at trees for the shade and shelter they give, at wildflowers for their delicacy

Eagles and hawks perch on the branches of dead lodgepole pines, like this one near Roaring Mountain, to watch for prey.

AFTER THE ASH

and color. But how often do we think about how plants came to be and how they're suited to the climate, geology, and altitude of the place?

I like Yellowstone National Park best in early spring. As snow melts, pooling in green basins, there is a sense of what organic life was like at its very beginnings: dust and gas swirling into planetary bodies; juvenile water—water contained in igneous rocks—leaking upward from volcanic vents; rocks grinding down into soil; plants colonizing bare ground.

Everything we see in Wyoming was once covered with shallow seas, and the sea is where plant life originated. The trees, grasses, forbs, and shrubs we see in the northern Rockies today are the result of millions of years of evolution from the simplest, microscopic, waterborne organisms and seaweeds into plants that first took purchase on land—lichens, mosses, and ferns.

It's said that a plant is an obstruction in the landscape: it stops sunshine, water, and minerals—gathering them, ingesting them, and giving back life-giving gases and food. Solar-powered, mineral-driven, an alchemist, and graced with beauty, a plant is a perfect example of the give-and-take balancing act of energy cycles within an ecosystem.

Haven for insects, birds, and mammals, a plant is habitat, shelter, food, and pollenizer; in death, its litter becomes fertilizer and compost for seedlings. Tapping what it needs from a place, it then influences the environment that gave it life.

Flowering plants and animals evolved together. The ability of plants to capture sunlight and transform it into another kind of energy goes along with the ability of animals to harvest, digest, and flourish on native grasses, willow leaves, tree bark, sap, seeds, nuts, leaves, and flowers. The four stomachs of ungulates—bison, elk, deer, and antelope—are designed to digest the cellulose in grass. And bunch grasses need to be grazed (not overgrazed) in order to flourish. Here we see another odd balance: how ecology influences evolution. Soil, water, climate, vegetation, and topography create niches for various species to come into being and survive, and the animals, representing an evolutionary dynamic, in turn, affect the shape of the land, the vigor and selection of plants, and the spreading of seeds. The circle of influence goes around and around.

There is scarcely a plant in Yellowstone National Park not used somehow by wildlife. Bark, branches, stems, leaves, flowers, seeds, fruit, roots, and sap are food for ungulates and for many rodents—squirrels, mice, marmots, and pika. Seeds, nuts, and berries are eaten by birds, mice, chipmunks, coyotes, and bears. The roots and tubers are food for ducks and muskrats. The flowers of geraniums, elk thistle, balsam root, and beargrass are eaten by animals who graze. Wild strawberries, strung on long tendrils throughout the high mountains, are a delight to all, especially to human passersby.

Also called wild lettuce, the yellow monkeyflower is a perennial that grows in the Lamar Valley. Very adaptive, it flourishes not only in rich meadow soils, but also in alkaline sinter around the park's hot pools. Native Americans ate the slightly bitter leaves as greens.

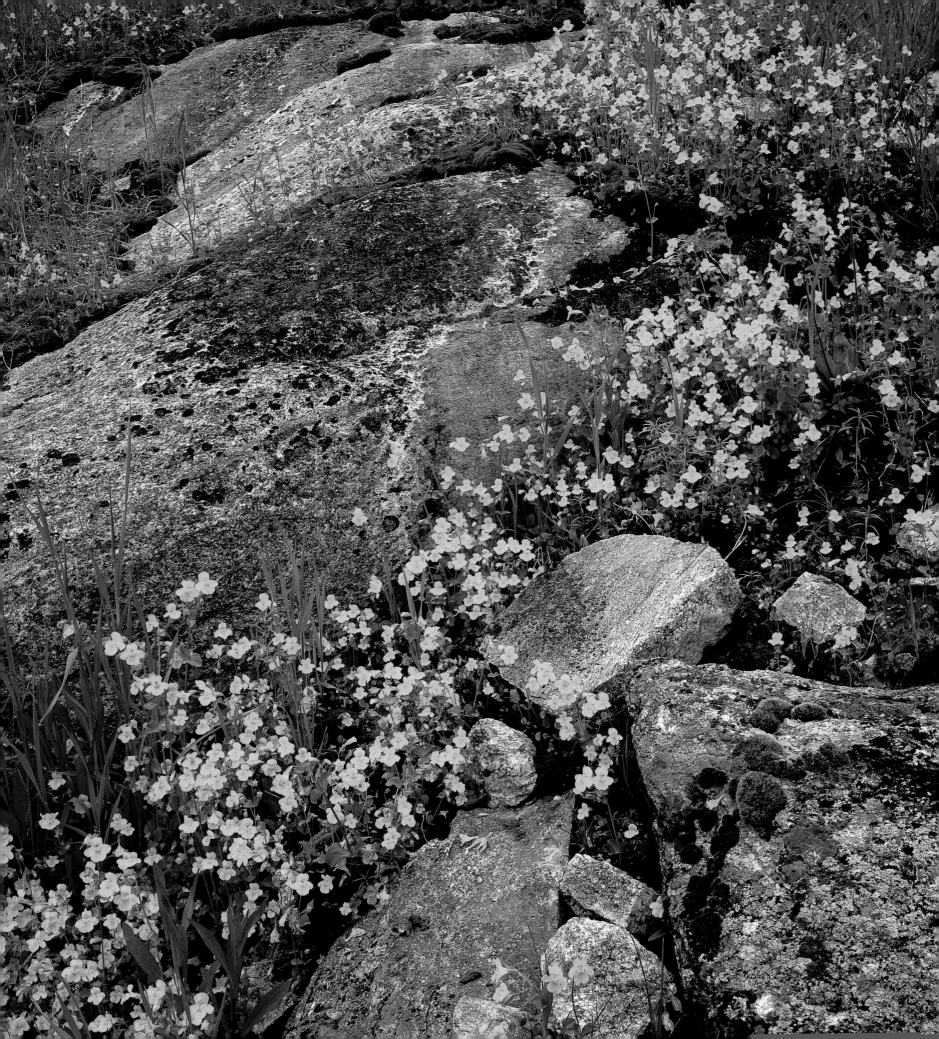

I*n the fall, aspen trees are bright torches on the Blacktail Plateau.*

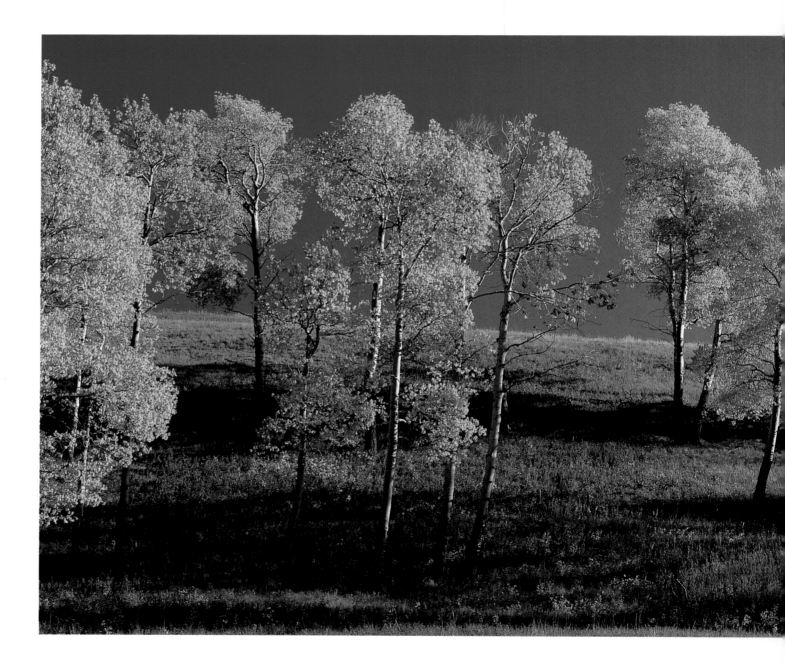

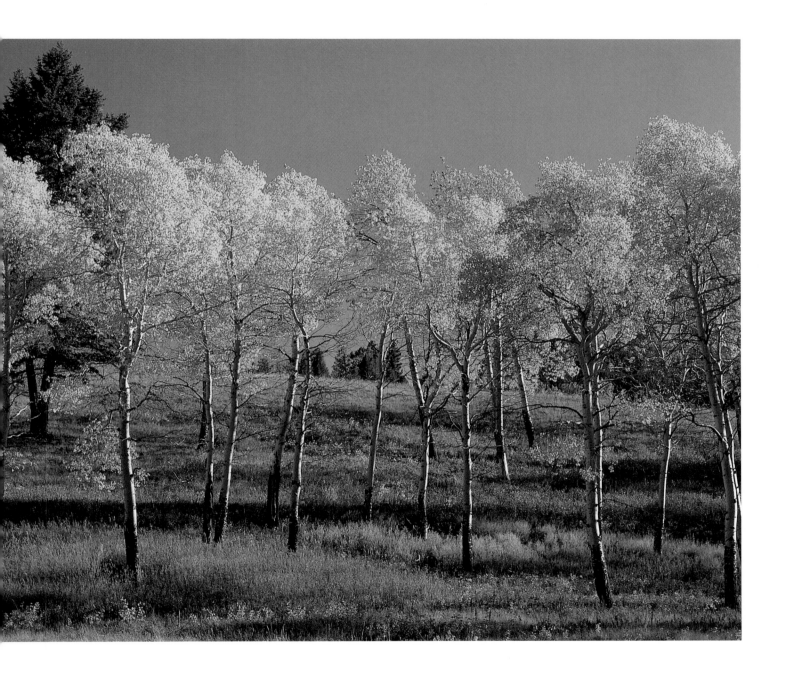

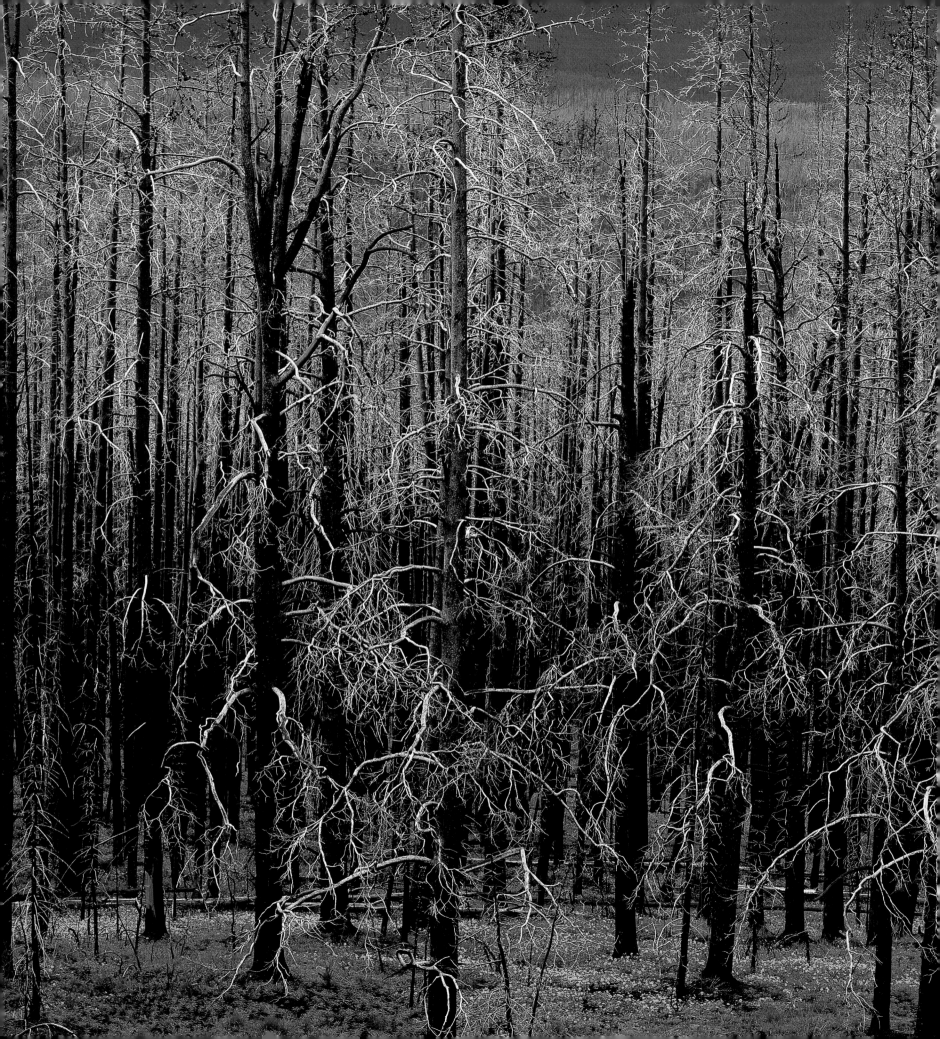

Plants grow in communities just as all animals do, including humans. Everywhere we look there is a rich web of connection, and the park's tapestry of vegetation tells us much about where we are. To know about plants is to know about the history of the planet and its weather, about the lives of animals and the medicines and tonics and foods made and used by humans who might also have come this way.

The thermal habitats of Yellowstone National Park place extraordinary demands on plants that grow within it. Yellowstone straddles the Continental Divide. Its altitude ranges from 5,130 feet to 11,358-foot peaks. Winters are long, harsh, and very cold, with night-time temperatures reaching forty degrees below zero, and during the short summers, precipitation varies from seventy inches in the southwestern part of the park to ten at the north entrance near Gardiner, Montana. The vegetation varies accordingly.

The park has eighteen habitat types—including grasslands, tundra, thermal, talus, and riparian, and nine kinds of forested areas—as well as five geologic-climatic provinces: the Gallatin Range, Absaroka Range, Central Plateau, Southwest Plateau, and the Yellowstone-Lamar Valleys. The bedrock type that distinguishes each of these areas produces differing soils as well as variations in topography that result in unique microclimates.

Black skeletons of burned trees below Mt. Washburn.

Although 80 percent of the park is covered with forest, fires have broken those monoscapes into smaller domains. Between are the geyser basins and various kinds of grasslands interlarded with berries, shrubs, aspens, and wildflowers.

The only endemic plant in the Yellowstone ecosystem—a plant that occurs only here and nowhere else—grows in a geyser basin near Old Faithful. It is Ross's bentgrass, a tiny annual grass that germinates in late winter and flowers before spring comes. It likes to grow where steam comes to the soil surface and condenses on the ground. Elk and bison who stay around these warm places in winter nibble at it and carry the seed to other hot spots nearby, thus ensuring a new crop the next year.

Another plant—the yellow monkeyflower—is uniquely suited to the extreme thermal conditions around Yellowstone's boiling geysers. In winter, the air temperature around a geyser can be seventy-two degrees, but a howling wind can cause the surrounding temperature to drop below zero.

The yellow monkeyflower has adapted remarkably to this harsh environment. In winter, a prostrate form of the plant lies below the frigid winds and grows in the alkaline sinter deposits near the vent. In summer, an upright form that grows elsewhere flowers from May all the way through September, when the elk start bugling and the tourists have gone home.

It's one thing to see a single, corrugate-seeded spurge flower blooming in January by the warm vapors of Old Faithful, but quite another to ride a horse for ten days through meadow after meadow luxuriously carpeted with wildflowers in midsummer: delicate blue harebells, buttercups, tiny bunched forget-me-nots, penstemon, the petalless western

coneflower, mountain gentian, elephant head, steershead, bistort, and elegant sego lilies . . . the list in my journals goes on and on.

Every hillside and flat is punctuated with red: Wyoming's state flower, Indian paintbrush. Their clusters of tubular red flowers are sometimes tinged scarlet. Semiparasitic, these plants produce only a portion of their own nutrient requirement. For the rest of their daily meal, their roots stealthily penetrate the roots of nearby plants and steal some of their food.

At nine thousand feet, it is still spring in July, and whole meadows are dappled with the pale sego lily and blue wild iris. I love riding through these flowers. In bloom, the wild iris is indigo blue, and later in the year its seeds rattle inside casings like castenets as my horse knocks them with his legs. The seeds of the wild iris were ground down by Indians to make a poison in which they dipped their arrows. The bulbs of sego lilies—white, tulip-shaped flowers with yellow centers marked with a purple spot—are highly nutritious when boiled and taste like potatoes. The Mormons ate quantities of them in their first Utah spring, before they had any gardens.

It is impossible to talk about the flora of Yellowstone without talking about fire. Fire is an ecological force in the Yellowstone ecosystem—just as rain and snow is, or the consequences of excluding a native species like the wolf, or the impact of too many people.

An average of twenty-two fires a year are started by lightning in the park. Many of the trees and plants are adapted to fire, have coevolved with it, and in some cases, depend on fire for survival. Fires open the dark overstory of climax lodgepole pine forests, enabling savanna and grasslands to grow, which in time provides room for other species of trees such as the Douglas fir and Engelmann spruce. After fires, tiny meadows appear where native bunch grasses, wildflowers, and berries pop up, creating habitats used by grizzlies, birds, squirrels, bees, elk, and bison, and many others.

The lodgepole pine dies in fire, but it also regenerates quickly from the scorching heat. This is what botanists call being "fire-adapted." Lodgepoles produce two kinds of seed cones. One of them, the serotinous cone, opens only after it has been heated by fire, while the seeds of its other cones are not opened by fire. Either way, the lodgepole will survive.

By contrast, trees such as the Engelmann spruce, subalpine fir, and Douglas fir are less well adapted and so less numerous in the park. Their seeds arrive via the wind, on the backs of birds, in the cheeks of squirrels, or perhaps caught in the sweater of a passing hiker.

Fires also affect the amount of sunlight plants receive. If there are fewer trees, there is more sun—and if there is more sun, there is more diversity in plant and animal life. Fires also influence the mineral cycle. By hastening the release of nutrients on the forest floor, fires provide a natural fertilizer for wildflowers. On the other hand, the heavy leaching and

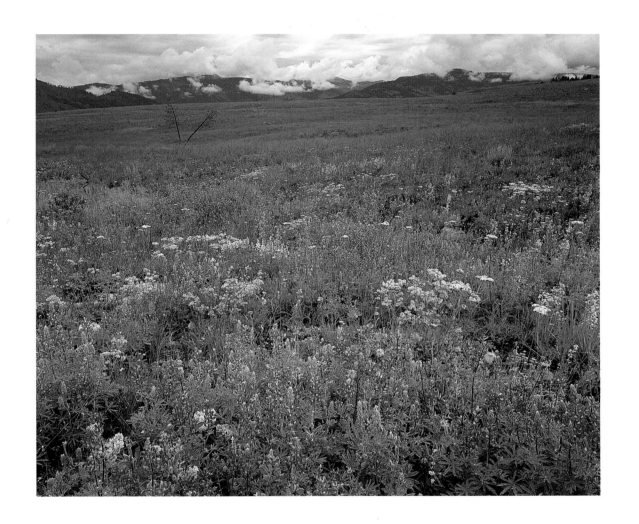

Lupine and sulphur flowers carpet this wide meadow. Sulphur flower is also know as wild buckwheat and grows well in dry soil at high altitudes. When young, the flowers are often rose-colored, but later they turn creamy white. The purple-headed lupines are part of the pea family and are poisonous to livestock when their pods are about to ripen. Lupines are a common sight throughout the Greater Yellowstone Ecosystem, where they are consumed by black bears and grizzlies, elk, and mice.

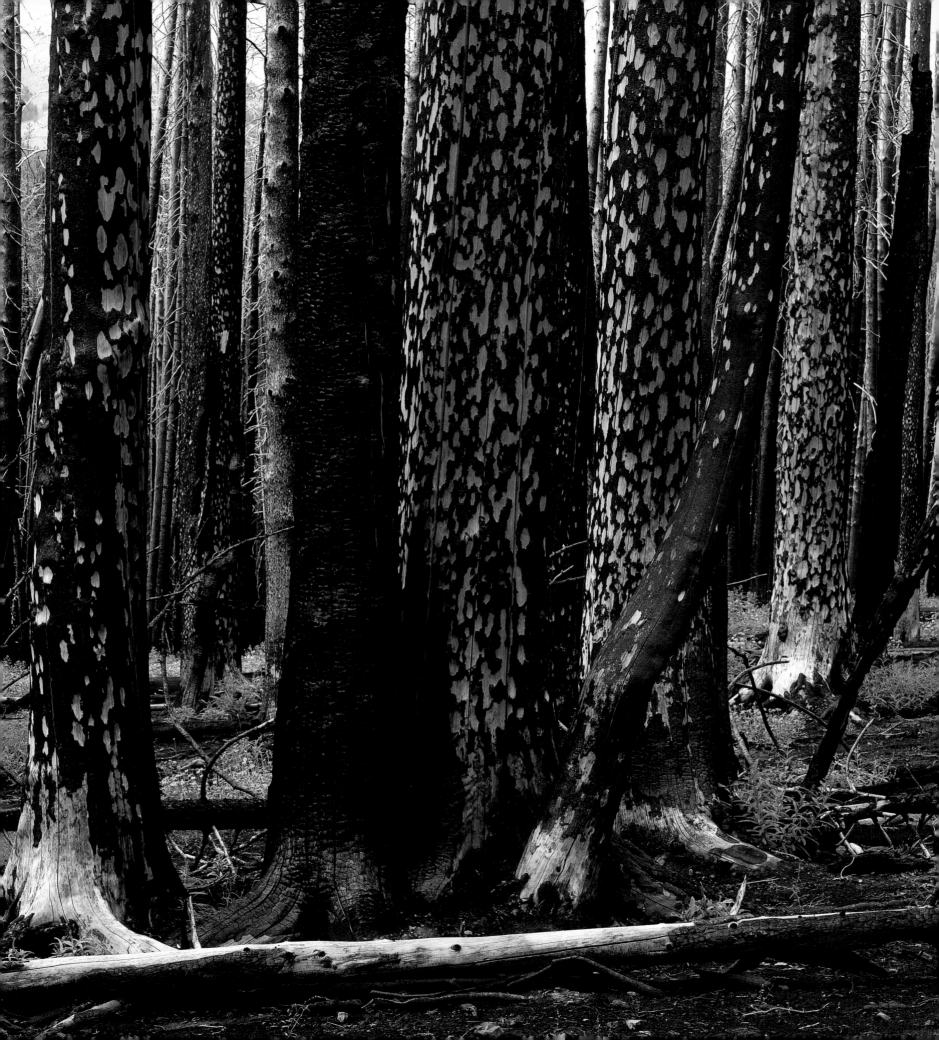

erosion that occurs after fires can soon drain minerals away, creating an environment more suitable to lodgepole pines than native bunch grasses or forbs. Plants that haven't taken up what nutrients they need very quickly after a fire will lose out, their seeds lying dormant for perhaps another hundred years.

Yellowstone is a wonderful place to observe the back-and-forth landscape dynamic of forest and grasslands—reminding us that what looks static isn't. The savanna created by fire won't always remain open ground. Somewhere on the edge of this microhabitat, a pine seedling will take hold, then another and another. The young plants will gradually influence the mineral cycle in the environment so that the ground becomes more amenable to tree-growing and less able to support sagegrass communities. Eventually, a small island of trees will come into being, and another, until these merge the way fires once did, holding hands across open meadows until the meadows disappear. But soon enough a new fire will spark in that place, and the forest will again give way to bare ground, then grassland.

"Everything you see in Yellowstone came from fire, has been wiped out by fire and grows back because of fire," a park botanist said to me. On August 20, 1988, "Black Saturday," 160,000 acres burned in the park during a twenty-four hour period. Fires that had been burning individually merged to become one vast conflagration, and at the same time, new, small fires ignited almost spontaneously. Crown fires, moving at tremendous velocities, formed a single umbrella of flame, and fires moving underground followed tree roots until whole groves of fir, spuce, and pine tumbled. The smoke rising out of these tinder-dry fuels blackened skies a hundred miles away.

By September 3, a total of 793,880 acres had burned in the park and surrounding national forests. A week later, the total had jumped to 1.2 million acres. When I looked down on the fire from a plane, I saw how trees, like fiery candles, had fallen against other trees, setting them alight. Whole areas of the park looked like black pickup sticks from above, and I wondered if anything of Wyoming would survive.

In early August, controversy raged over whether to contain these burns or allow them to run their course as "natural fires." Black Saturday rendered those questions irrelevant. The irony, of course, was that the fires became so big that no human force could have stopped them.

Looking over a fire-blackened meadow a year after the burn, a park biologist grinned: "From the plant's point of view, nothing unusual has happened. Fires of this magnitude are only odd to humans because they might happen only once in our lifetime. But there are cycles of fire and drought that are just like the yearly cycles of seasons. Snow and summer heat cause death and disturbances in nature, but that seems normal to us. We expect it. Yet from the fire scars on the old Douglas firs and the charcoal deposits in this area, we

This stand of lodgepole pines near Mt. Washburn was burned during the 1988 Yellowstone fires. The fire-adapted cones have already opened and thrown their seeds. Fire also opened up the forest's thick shade, and sun shines through its broken canopy. Beneath the trees, grouse whortleberry has taken hold. The small shrub has red berries that are eaten by bears, coyotes, birds, and rodents.

FOLLOWING PAGES:

Fireweed colonizes soil that has been disturbed by humans, landslides, erosion or fire. That's why it is seen by the sides of roads and in the burned areas of the park. Long-stemmed and bright, its purple flowers turn red in the fall as if they had been burned by the summer's hot light.

*S*ticky geranium is pink-petalled and rises from a wood root. The stems of its flower clusters are covered with sticky, glandular hairs. Elk, deer, and bear dine on all parts of the plant, while moose, who are fussier, consume only the flowers.

know that fire has been a common thing. These forests have burned thirty times since all this vegetation came out from under the ice."

Six years after Black Saturday, I again stood on the edge of a wide sagegrass meadow, now green except for the remnants of dark circles where the sagebrush had burned so hot that the organic material in the soil was killed. Plants will reclaim those patches too, just more slowly. Where six years ago the entire meadow had been black, now it was thick with lupine and native grasses: Idaho fescue, bluebunch wheatgrass, Richardson's needlegrass, lamb's quarter, and penstemon. Lupine had been one of the first plants to colonize burnt ground. As the bumpy seedpod dries, it twists open, releasing mauve seeds that germinate quickly after a single rain.

To call a plant a weed is only a cultural bias. To other plants, they are first-comers who keep the soil alive. Successional complexity is best seen after a fire: colonizing plants that like disturbed or ashy soil come back first, followed by forbs, grasses, and trees. What we may think of as weeds are usually those first opportunistic plants, and their function in maintaining the energy cycles of the planet are important. The soil surface is the earth's skin, and a covering of vegetation keeps the soil healthy.

From Blacktail Deer Plateau, I tried to get a wider perspective on the fires. Turning 360 degrees, I saw the random ways the fires had traveled. Runnels of brown mixed with green. Where fire had moved fast, one side of the trees was dark, needleless, and branch-less, while the other side was bushy and green.

Fires jump, dance, and zigzag. Much of the park's 2.2 million acres was untouched by flames. The velocities of the fires were so great that they leapfrogged, blowing themselves out, fanning themselves into existence again. Very few areas were completely blackened.

What I learned that afternoon was that fire is not simply a destroyer, but part of the many cycles of growth and regeneration. Even in the places where the ground has remained black for several years, the soil below is brown and healthy. Only the top part has lost its living material, but even the upper layer of "sterilized soil" is a habitat for that amazingly adapted tree, the lodgepole pine. So there will be pine here, and a few yards away there will be wildflowers.

Toward Tower Junction, I walked through a stand of Douglas fir that had been blackened by a crown fire. It will be three hundred years before the trees recover fully from the blaze. Then I looked at the ground, and what I saw was astonishing: knee-high pinegrass was in flower, fertilized and stimulated into bloom by the fire. No one in my lifetime has ever seen this particular grass in flower—and next year, the park biologist told me, the blooms will be even lusher, thanks to the fire's effect on the soil.

In fact, you can trace the path of underground fires that have burned tree roots—not by following lines of blackened soil but by observing the meandering, fire-activated lines of flowering pinegrass and lupine beneath groves of two-hundred-year-old trees.

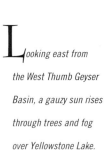ooking east from
the West Thumb Geyser
Basin, a gauzy sun rises
through trees and fog
over Yellowstone Lake.

Farther on I saw a forb, wide and circular with big leaves, low to the ground: Bicknell's geranium. It germinates, flowers, and produces seeds only in that first year after a fire. Then it waits for the next blaze. Until then, whether it has to wait five years or a thousand years, its seeds lie dormant.

The amazing endurance of plants and their seeds has been proven by the fire. Hidden underground, rhizomes, bulbs, corms, root crowns, and seeds can withstand temperatures exceeding three hundred degrees Fahrenheit. Since the fire, seed densities in the park's forest stands have been measured at between a hundred thousand and three hundred thousand per acre.

Plants have mechanisms for surviving fire and other threats that are far more intricate than we have imagined, and it's here in the park that some of them have been discovered. Some plants that have been overgrazed, for example, produce toxins that make them unpalatable—the end result being that the offending animal population eventually declines. A chemical has also been found in young wheatgrass that can influence a mouse's reproductive system, triggering it in a wet year when food is abundant and turning it off in a dry one when there is less to eat.

We tend to think of causation in a hierarchical way, from the top down. But now it's being found that a little plant on the ground can affect whole animal populations. The dominoes don't always fall just one way.

At the end of the day, I knelt down on a north-facing slope. My hand grazed a Douglas fir seedling with soft gray needles, its miniature trunk no more than an inch high. Fire endemics—like the geranium—and millions of new seedlings suddenly appearing showed me how quickly life hooks onto death—how surely fire is both destroyer and sower.

On a slope near Mt. Washburn, a stand of fireweed is bright against blackened trees.

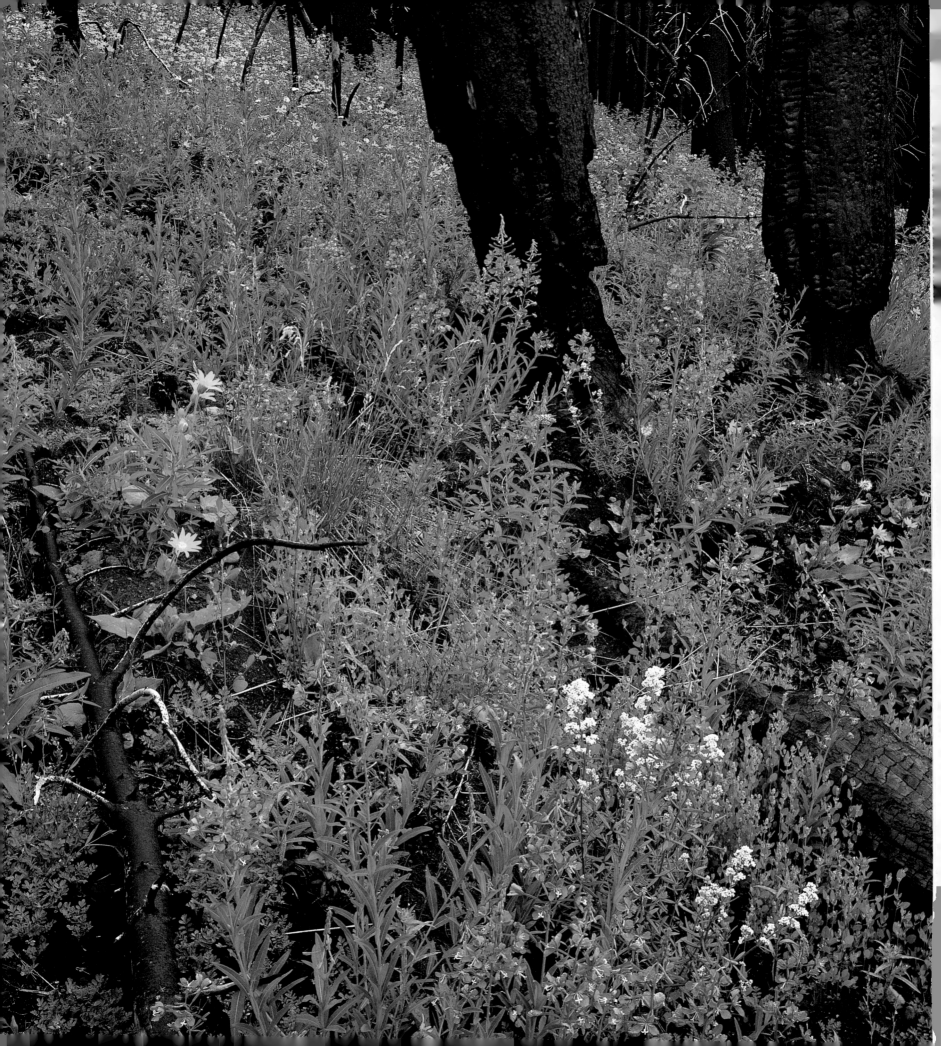

Heartleaf arnica blankets the valley floors near Mt. Washburn. Its bright yellow blooms are a sharp contrast to the burned and crumbling logs beneath.

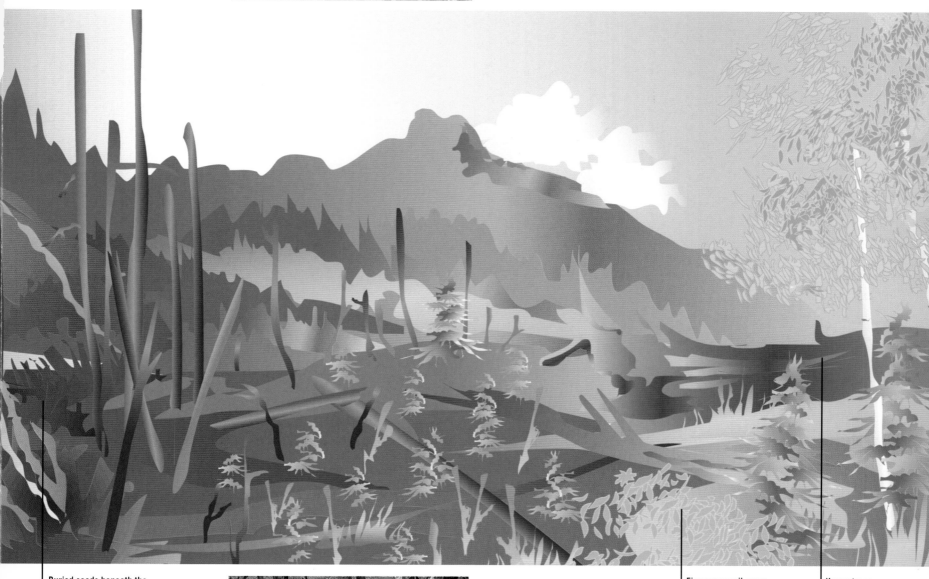

Buried seeds beneath the forest floor are warmed by the fire and germinate, propagating new growth of weeds, wildflowers, and bunch grasses.

Fall-colored underbrush carpets the caldera rim near Virginia Meadows.

Fire opens soil, once covered by forests, to the sun, enabling new grasslands to flourish.

Young trees take root, regenerating the woodlands.

Fire is a natural force that helps regenerate healthy forests.

Hundreds of young seedlings rise up at the base of trees blackened and charred by the firestorm of 1988.

and winds were high. And because of the park's policy of fire suppression, masses of tinder-dry underbrush had built up throughout the park. The conditions were ripe for a firestorm.

Fires that had been ignited in Yellowstone that year by lightning strikes and human causes finally merged into a single, huge conflagration. By September, 1.2 million acres of Yellowstone and surrounding national forests had burned.

Both woodlands and meadows were consumed by the flames, and in many places the land was laid bare. But native seeds are remarkably hardy. Fires do not destroy the seedbank—the millions of plant seeds that are always lying dormant in the ground.

Opportunistic plants—what we call "weeds"—quickly colonized the burned ground. These "weeds" were a blessing, protecting the singed soil and acting as a temporary cover until native perennials could take hold again and a new forest could take root.

Wildfires destroy old growth, ridding forests of dead trees and dense underbrush.

PLANT SUCCESSION—
THE HEALING HAND OF FIRE

Fire is as natural a part of Yellowstone's ecosystem as rain or snow. For ten thousand years before Europeans came to the West, fires ignited by lightning strikes or Native Americans were a regular occurrence. The vegetation adapted itself to the cycles of fire and regrowth.

Flames clean out deadfalls, underbrush, leaves, and pine needles. They open up the forest canopy so that grass and wildflower seeds can germinate and a more diverse ecosystem can flourish again. Some plants, such as Bicknell's geranium, are entirely fire-activated and appear only the year after a blaze. Then they go dormant until flames sweep through again.

But because large wildfires, like blizzards, cannot be controlled, they are terrifying. The conflagration that burned more than a million acres in the Yellowstone area in August and September 1988 was so fierce and unpredictable that no human effort could have stopped it.

That summer had been the driest season on record in the western United States. It had followed years of drought, and no precipitation was in sight. Temperatures

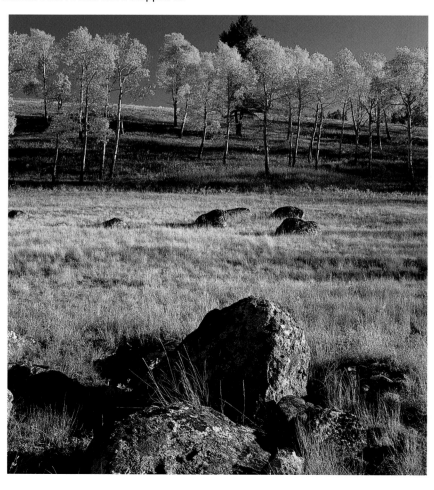

On the wide open slopes of Blacktail Plateau, white-trunked aspens show their fall colors.

The ash after a fire increases the water-holding capacity of the soil—benefitting all vegetation, especially thirsty aspen trees.

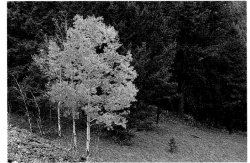

Young forests become old-growth forests, and the cycle of fire and regrowth eventually repeats itself.

Sticky geranium colonizes grassy meadows that spring up where forests have burned.

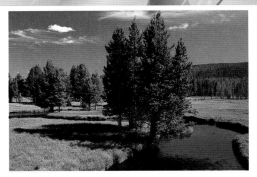

After the weeds, native bunch grasses and wildflowers created a grassland where forest had been before September 1988. Sagebrush—*artemisia*—burns hot and did not survive, but its seeds did, and sage seedlings have sprouted up everywhere amid the charred stumps of lodgepole pines, spruces, and firs.

The seeds of the fire-adapted lodgepole pines survived, as well. One kind of lodgepole pine cone opens and spreads seeds only when it is heated by a fire. Throughout the park, small seedlings of lodgepole pine, Douglas fir, and spruce have taken root in the new, open grasslands, regenerating the forests and completing the cycle of plant succession and regrowth.

A wide meadow
near Obsidian Cliffs.

Lily pads on
Isa Lake.

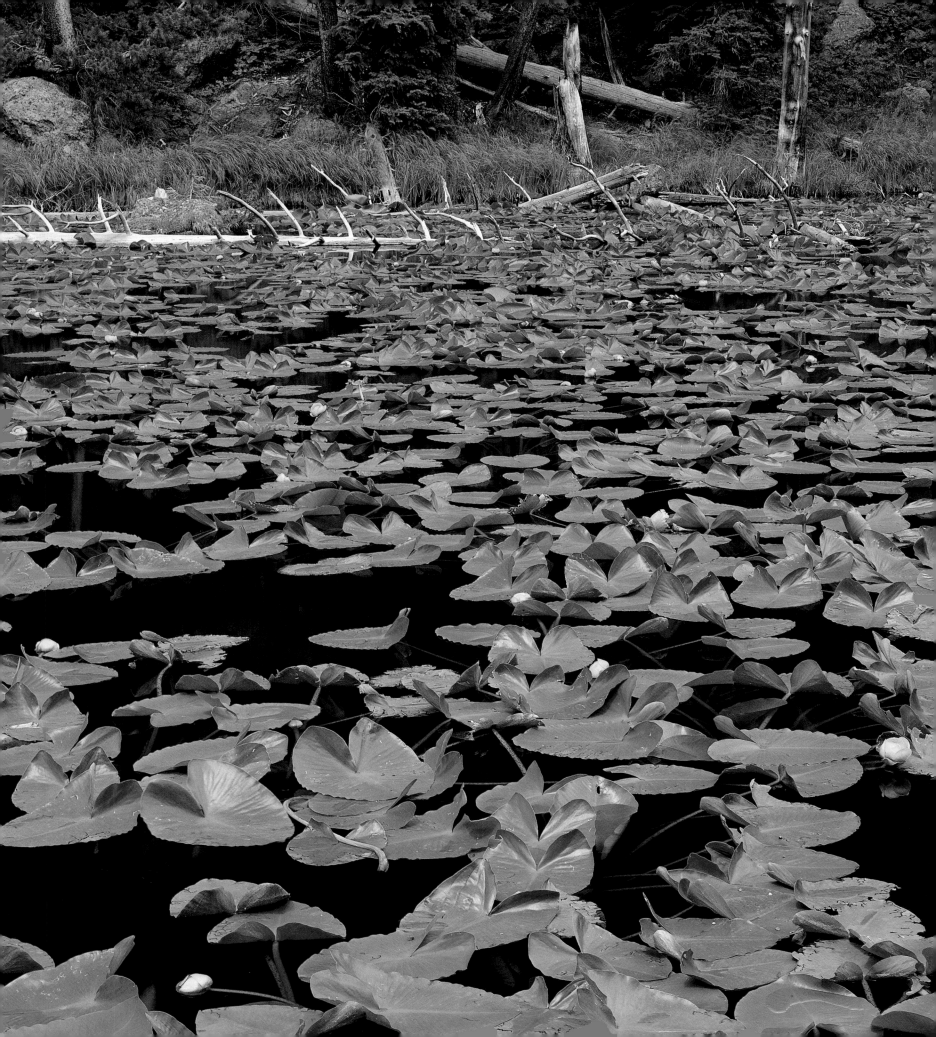

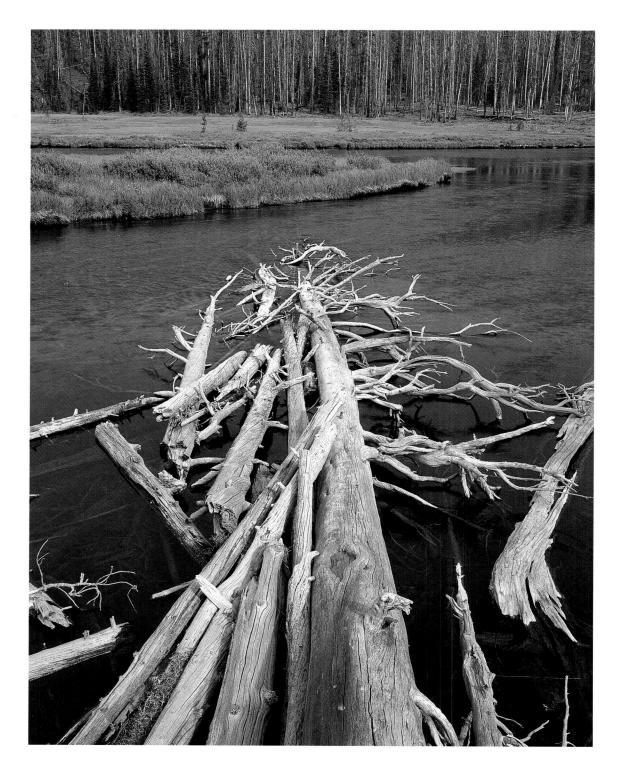

The 1988 Yellowstone fires burned a swath through lodgepole forests along the Lewis River. The deadfall will slowly rot and add nutrients to the soil and water.

THE ASPEN STORY

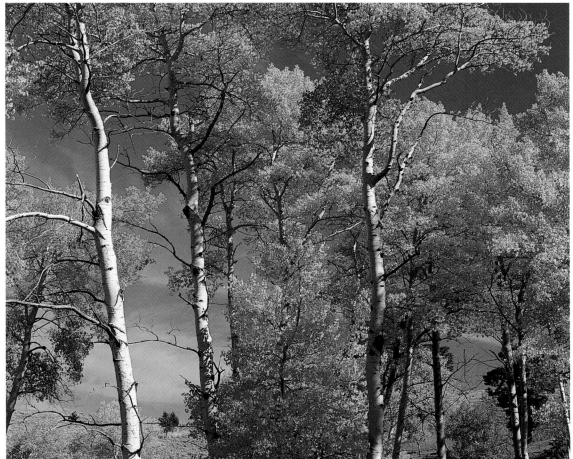

Afavorite tree of westerners because of its graceful beauty, the aspen colonizes landslides and lives well at high altitudes. Most of the aspen groves in the Rocky Mountains were established at the end of the last Ice Age, when mammoths and early horses roamed the region. The groves' long-term survival may have been aided by their unusual colonizing mechanism. The main bulk of the aspen tree lives underground, with a lateral root system that sends out shoots to form new groves. While the above-ground portion of the tree is vulnerable to forty species of fungus, as well as to severe grazing by elk, there are only two types of fungus that can kill the aspen's roots.

Aspens, however, are water-hungry and don't survive competition with other plants, which is why they favor the disturbed ground of a landslide. After the 1988 Yellowstone fires, it was found that ash had a water-holding capacity which benefitted all vegetation, especially the aspen.

FOLLOWING PAGES:

Fire is a natural component of the Greater Yellowstone Ecosystem. Already, these young lodgepole pine seedlings thrive amid the deadfall near Elk Park.

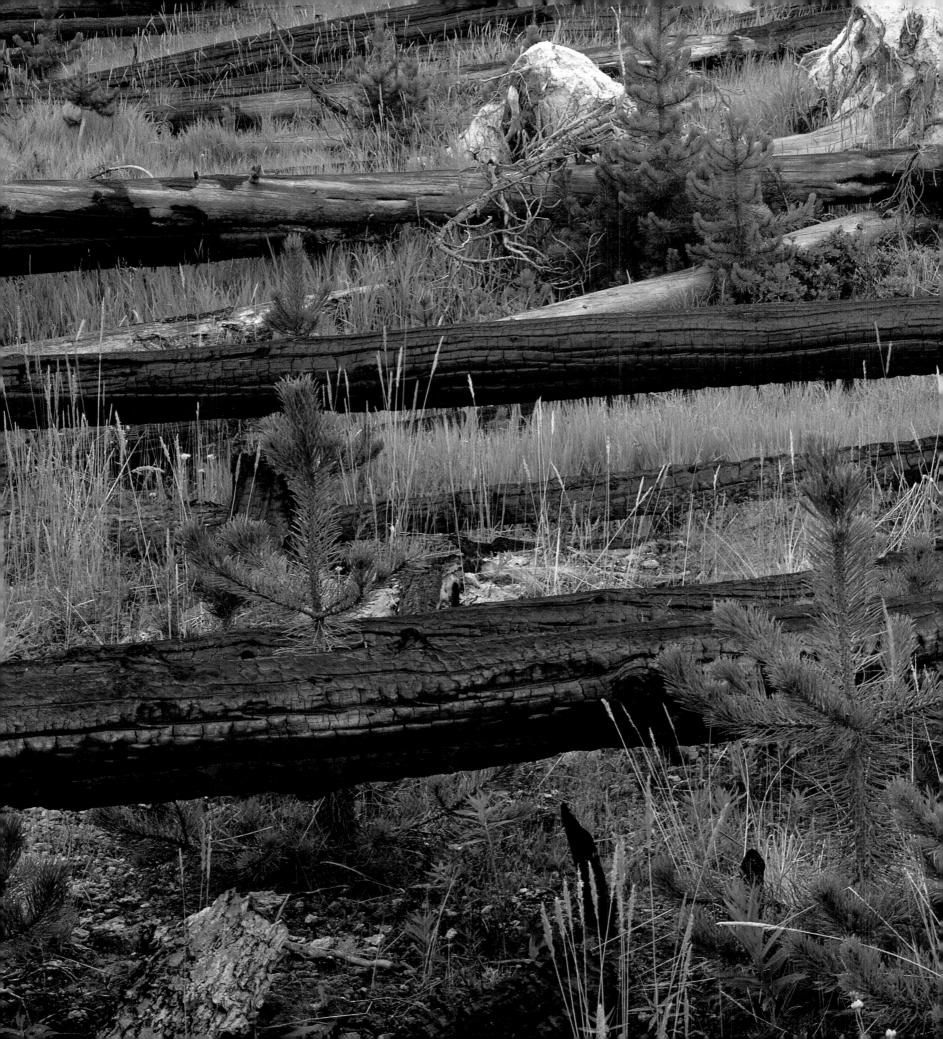

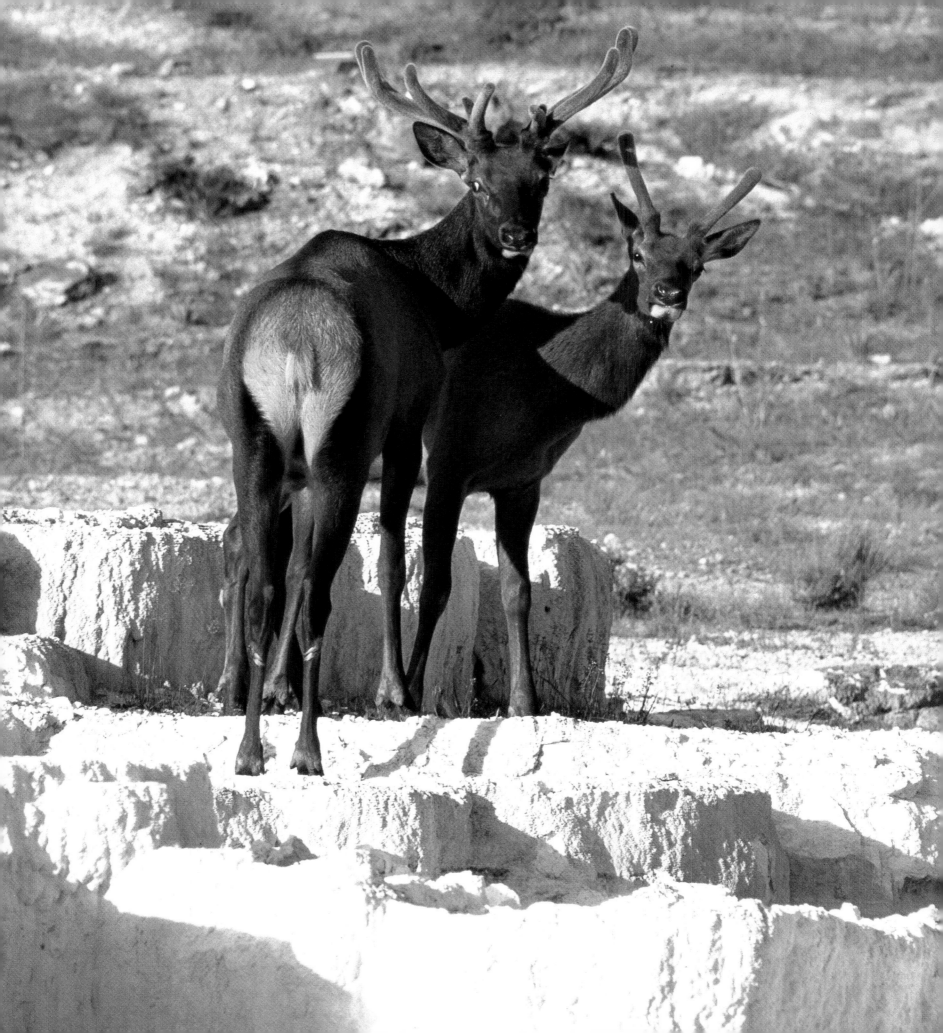

The Yellowstone region is the largest intact ecosystem in the temperate region of the earth. A whole ecosystem is one in which plants and animals—as well as minerals, water, and solar cycles—are all complete and working in a balanced way. These relationships are more intricate than we ever knew. The health of the soil, for example, will be endangered from overgrazing and erosion if there are too many elk, and too few wolves to prey upon them. If there is erosion, then the fisheries will go downhill, and if those go, the river otters will decline—on and on it goes.

Too often visitors come to the park to see a bison or a grizzly bear, as if a wild place could be as neatly arranged as a zoo. To understand the unique balancing act of animals in the ecosystem, one must contemplate the entire biological web, from microorganisms, insects, small mammals, fish, and fowl to those most famous residents—the bears, coyotes, and bison.

To see one animal is to see the whole invisible network that keeps that animal alive. If you see a bear, you know that there are berries, fish, grubs, and carrion such as deer, bison, and elk. If you see bison, you can assume that the soil is healthy, full of microorganisms and with a decent water table, so that native grasses, upon which bison feed, can grow.

To know an animal, you must know where and how it lives in each season—which drainages it likes, which valleys and rivers, where it finds protection and food in the winter, where it sleeps, where it dies and how. In knowing an animal, you become intimate with

Two young male elk in velvet. In autumn, bull elk spar with other males as they vie to breed with females that are gathered in harems. The long, looping whistle of bugling elk helps attract females and scare off rivals.

THE WEB OF LIVES

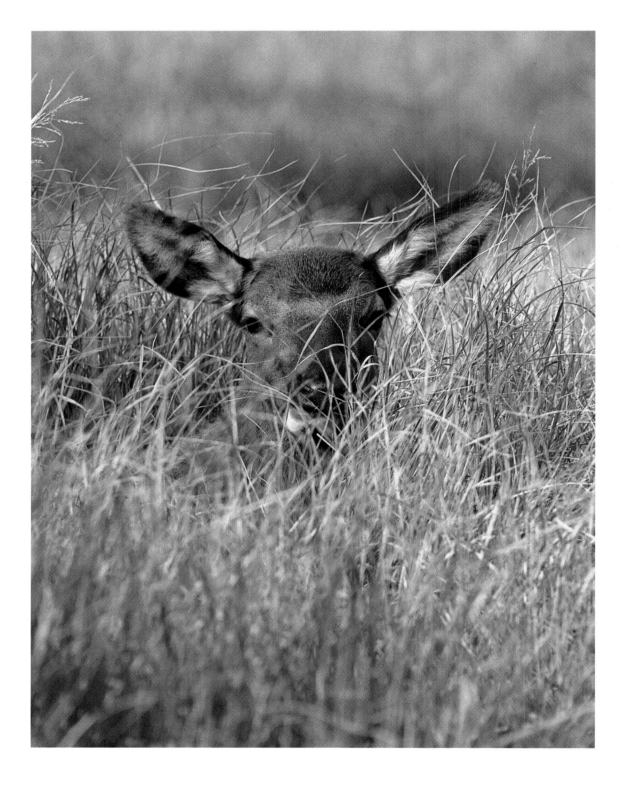

*S*unning herself in
the meadows near the
Gibbon River, a young
elk calf hides behind
tall grass.

the land. You learn to read the landscape: where the bear dens are, the heron rookeries, the coyote lairs, the trees under which the bison sleep. You learn the rivers, the kinds of grasses—fescue from bluebunch—as well as trees: aspen from willow, fir from pine. And in order to understand the geography of these plants, you come back to geology—to the violent beginnings of these continents, the interplay of fire and ice, the genesis of the volcanic paradise that has become home to so many wild beings.

Spring comes late to the Yellowstone Plateau. In the beginning of May, there are still two or three feet of snow on the ground at the higher altitudes, and lower down, meadows have turned to lakes of meltwater. In the Hayden Valley, bison slog through mud, and the carrion of elk and deer are everywhere. Ravens lead coyotes to winter-kills, and eagles circle overhead, waiting their turn. A grizzly bear—just out of his den, still sluggish and thin—lumbers down a slope, turns a log over, and searches the wet ground for grubs, then stands and sniffs the fresh spring air.

Ursus arctos horribilis, the grizzly bear, is perhaps the park's most famous resident. Our fascination with bears began long ago. Bears migrated from Eurasia across the trans-Bering land bridge during the second glaciation period, along with saber-toothed cats. It wasn't until the third glaciation period that bison, deer, elk, foxes, wolves, weasels, and wolverines made the crossing to North America.

More than any other animal found in the park—and there are fifty-eight species of mammals alone on the park checklist, including four kinds of voles, six varieties of bats, three shrews, and two species of deer—bears pique our curiosity and imagination. No other Yellowstone mammal so resembles a human.

Bears are omnivorous. In other words, like humans and coyotes, they are adaptable and opportunistic. In the spring of the year, as they come out of hibernation, their diet is mostly vegetarian—grasses and edible flowers, tubers, and the salads a hot spring can support: miner's lettuce and watercress, with a few grubs thrown in for protein. Later on, they dine on the carrion of winter-killed elk, deer, and bison. When the streams clear up, fish are added to their diet, along with snowberries, huckleberries, serviceberries, gooseberries, and thimbleberries, to which they add whitebark pine nuts from the high country.

Grizzlies seem human because they rise up on their hind legs, standing as humans do. They move their powerful arms like athletes and use their claws as if they were fingers. I've seen them hold bowls of honey and open doorknobs to let themselves into forest service cabins loaded with food. The large track of a bear's hind foot, with its heel and sole pressed into the dirt, will send shivers down your back: I can press my heel into its heel print, and it fits.

Like humans, bears are at the top of the food chain. Since we are a bear's only predator, it makes sense that they should, from time to time, predate upon us. Humans were

once very much a part of the predator-prey relationship that strings the animal kingdom together. But with the demise of hunting and gathering in the human community, and the maniacal killing frenzies of frontier days, we have skewed the entire ecosystem.

Perhaps our urge to kill bears is simple jealousy. In terms of physical prowess, bears outmaneuver humans every time. They run faster, up to thirty-five miles per hour, are better swimmers, can live and travel in harsher climates with stealth and speed, and can gain enough weight while foraging in the summer to live off their thirty-five hundred calories per pound of fat all winter long. Their physiology is engineered for survival: their hearts are large, and because their aortas are thick-walled, they are less vulnerable to death by bullets and arrows. Even so, despite the fact that grizzlies are protected under the Endangered Species Act, their lives are often ended by gunfire, since half their range lies outside the park boundaries. There they come in contact with hunters who can't tell the difference between a grizzly and a black bear, or with men who just want to kill something.

The most extraordinary physiological feature of the grizzly is its ability to hibernate and bear young in the den. In preparation, bears eat and eat all summer long, gaining as much as two or three hundred pounds, so that by fall they've had their fill. Then, when the heavy snows come in October or November, the bears' physiology begins to change. Their summertime high-fat and cholesterol diet—enough to cause coronary disease in a human—is the storehouse for a long winter fast. Bears do not suffer from arteriosclerosis because their metabolism is more efficient than ours. The blood proteins that transport fats do not deposit them on the blood vessel walls. During its prolonged sleep, a bear does not eat, drink, defecate, or urinate, and females have their young while in the winter-tight lair.

Den sites are selected with a sure sense of protection and privacy and a flair for aesthetics. Bears don't just dig a hole wherever they happen to be when the first snows fall. They will often travel many miles to a den site selected earlier—perhaps on a precipitous slope by a waterfall or under overhanging rocks on a south-facing slope, with a view of the world.

Dens vary the way all houses do. But there is usually an entryway through a long tunnel and a sleeping room sporting platforms covered with soft pine-bough beds for warmth. Because of the need to be secretive, bears will wait until the snowfall is heavy and constant enough to erase their footsteps to and from the den while they are building.

Grizzly bears once roamed the world. They inhabited the plains and coasts as well as the mountains. For Native Americans, grizzly and black bears have been creatures to be feared and revered as a sacred enemy. They have been called upon for both their healing and destructive powers. Early Spanish and Portuguese explorers documented sightings of grizzlies in California in the mid-1500s. Lewis and Clark observed bears along their journey during the years 1804 to 1806 and found them to be "terrible creatures hard to kill."

Unfortunately, all we did was kill them, until they became extinct in all states except Wyoming, Montana, Idaho, and Alaska. In the brittle and arid climate of the Rocky Mountain west, a bear needs up to three hundred square miles of home range, relatively unimpeded by humans, roads, helicopters, houses, and pipelines. In Yellowstone, with its immense monoculture of lodgepole pine forests, bears feed in a jigsaw puzzle of microhabitats, and the size of their range has to do with the need to travel between the "islands" where feed is good: places where there are berries, fish, pine nuts, or carrion.

The challenge to Yellowstone National Park biologists has been to maintain the endangered grizzly bear population and keep it on the rise. So far, it's been a success story. Grizzly bears reproduce only every two or three years, and if there are twins, odds have it that only one will survive. In ten years of a female grizzly's life, she will have given to the world perhaps only one or two cubs at best. Out of Yellowstone's remnant population of a few hundred bears, the death of one cub or one adult female strikes a blow to the future of the species.

In addition to the grizzlies, there is a thriving population of black bears in the Greater Yellowstone Ecosystem. Smaller than grizzlies, black bears are fast runners and good tree climbers. Omnivorous, they eat a wide range of park delicacies—including trout, chokecherries, pine nuts, sedge, and venison.

One May, I saw coyotes loping across the wide meadows of Hayden Valley, their coats looking like tarnished silver. Still carrying an underfur of thick down, their guard hairs were rust, black, and gray against cream, and their bushy tails floated above sunlit snow.

Canis latrans, the coyote, is the other famous opportunist in the park. This original being-turned-trickster of Native American legends is renowned for his uncanny adaptability and evolutionary stability. According to biologists, the coyote has undergone very little change in two million years. Although over the past ten million years the bear-dog, the hyena-dog, and the great dire wolf have vanished, the coyote remains. The Aztecs had a name for the animal—*coyotl*—from which the Spaniards derived "coyote." In some Native American mythology, the coyote is in charge of daylight and darkness, heavy rain and gentle rain, thunder and rainbows. The Crow Indians say: "How water came to be, nobody knows. How Old Man Coyote came to be, nobody knows. But he was, he lived." They say he created life on earth when it was still covered with water by telling the ducks to bring up mud, from which the coyote fashioned more ducks, more coyotes, prairie chickens, and bears. Having created all this, he climbed down into the world to make mischief and flaunt his sexual powers. The Crow say, "In one way or another everything that exists or that is happening goes back to Old Man Coyote."

Though the population of coyotes as a whole has diminished, their range has expanded. Originally the animal was found only west of the Mississippi, north to Alaska, and south to Costa Rica. Now they are found everywhere on the North American continent.

One of the keys to the success of this species is flexibility, adaptability, and intelligence. Coyotes can make it in suburbia as well as in the wilds of the Yellowstone Plateau. They can live alongside humans or in wilderness. With their catholic tastes, coyotes can find a

meal almost anywhere. Park coyotes love rabbit, but they also eat deer, elk, and bison as well as many smaller mammals, songbirds, insects, and fish. On examining the contents of one coyote's stomach, a researcher found one robin, one blackbird, one meadowlark, and one bluebird. The stomach of another contained five hundred grasshoppers, while a third had consumed trout, rosehips, and thimbleberries.

One spring afternoon I saw a coyote bring a fawn down. The chase began in a meadow mosaic of snow, meltwater ponds, and new green grass, then crossed the road, ending on the frozen ice of Yellowstone Lake. Out there, the coyote finally grabbed the fawn's back leg, and down she tumbled. He leapt high, then pounced on her neck, killing her. When she lay still, the coyote crouched down for a moment, then took a foreleg in his mouth and gleefully swung her around and around on the ice. When he had rested, he began eating and was then joined by ravens and other coyotes. When I came back the next morning, only the ribcage was left and the untouched, severed head. And later still, sleeping in the back of my pickup truck, I heard coyote voices everywhere, echoing across the dark caldera.

"Song-dogs," as they have been called, are the most vocal of all North American mammals. Phillip Lehner, a biologist who has recorded thousands of coyote vocalizations, reports that a coyote's vocal repertoire consists of eleven distinct sounds: a growl, huff, woof, bark, bark-howl, whine, wow-oo-wow, yelp, lone howl, group howl, and group yip-howl. They defend territory, give general warnings of danger, greet one another, locate themselves for each other, and sing for the hell of it.

Lying in the dark of that spring night, I wondered what those coyotes were saying, what they were able to say, and how those sounds were understood by others—what they knew that I couldn't know, and where their next meal would come from.

Another May evening at the southern end of the park, where there was still a foot of snow on the ground, I watched six or seven coyotes hunting for mice on a big flat. They leapt and pounced and, every once in a while, caught one. But at dusk, they stopped, gathered in a circle, and began to howl. There was no full moon, no obvious explanation for it. But then again, why not? After a ten-minute-long serenade, they dispersed and went their separate ways.

A coyote's sense of hearing is so acute, one biologist told me, "They can hear a mouse scratching fleas under two feet of snow." Their three-lobed brains show signs of complex cortical folding: the wise trickster thinks on his feet, sizes up situations, communicates well, and rarely makes the same mistake twice.

Nowhere is the dexterity of the coyote more pronounced than in its social groupings. Franz Camenzind, a biologist, noted four distinct groups. The first is made up of coyote families. In the winter, coyotes choose mates and then have pups in March. These serially monogamous pairs stay together for the entire year, and sometimes a lifetime. While the mother nurses her young, the father brings food. They take turns guarding den sites,

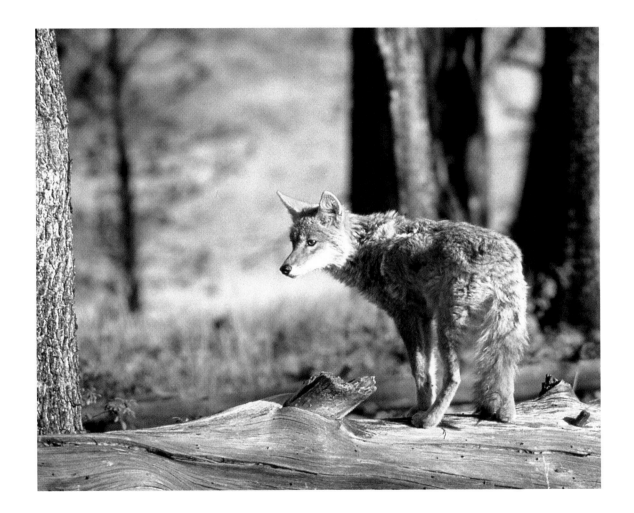

A female coyote stands for a moment, perched on a fallen log in the Lamar Valley. Extraordinarily adaptable and found everywhere within the park, coyotes will eat almost anything—including voles and mice, fruits and nuts, fish, grasshoppers, flies, and songbirds.

A yellow-bellied marmot peeks out from its rock house. Rather slow-moving animals, marmots emit a piercing whistle when approached. They can be seen lounging in the summer sun on outcroppings of rock high in the mountains.

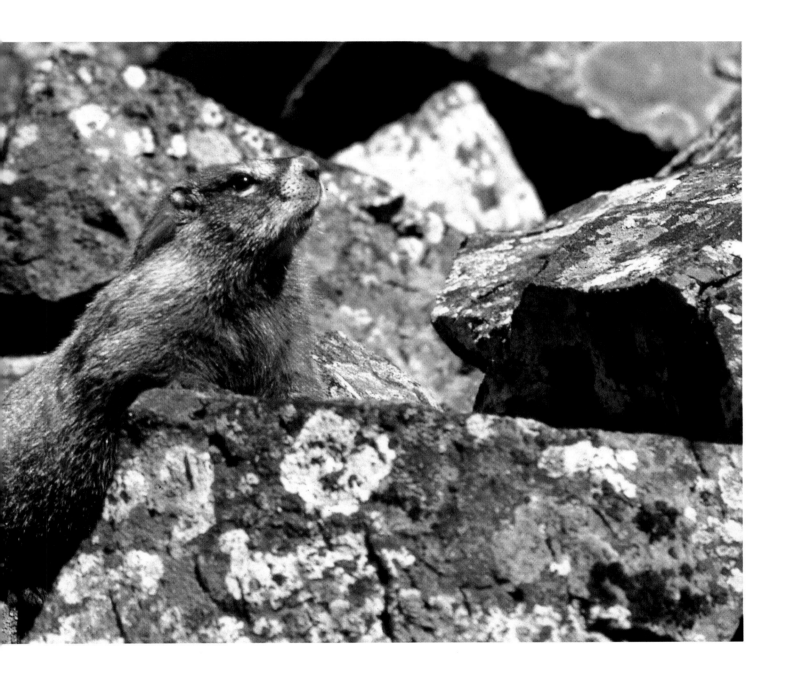

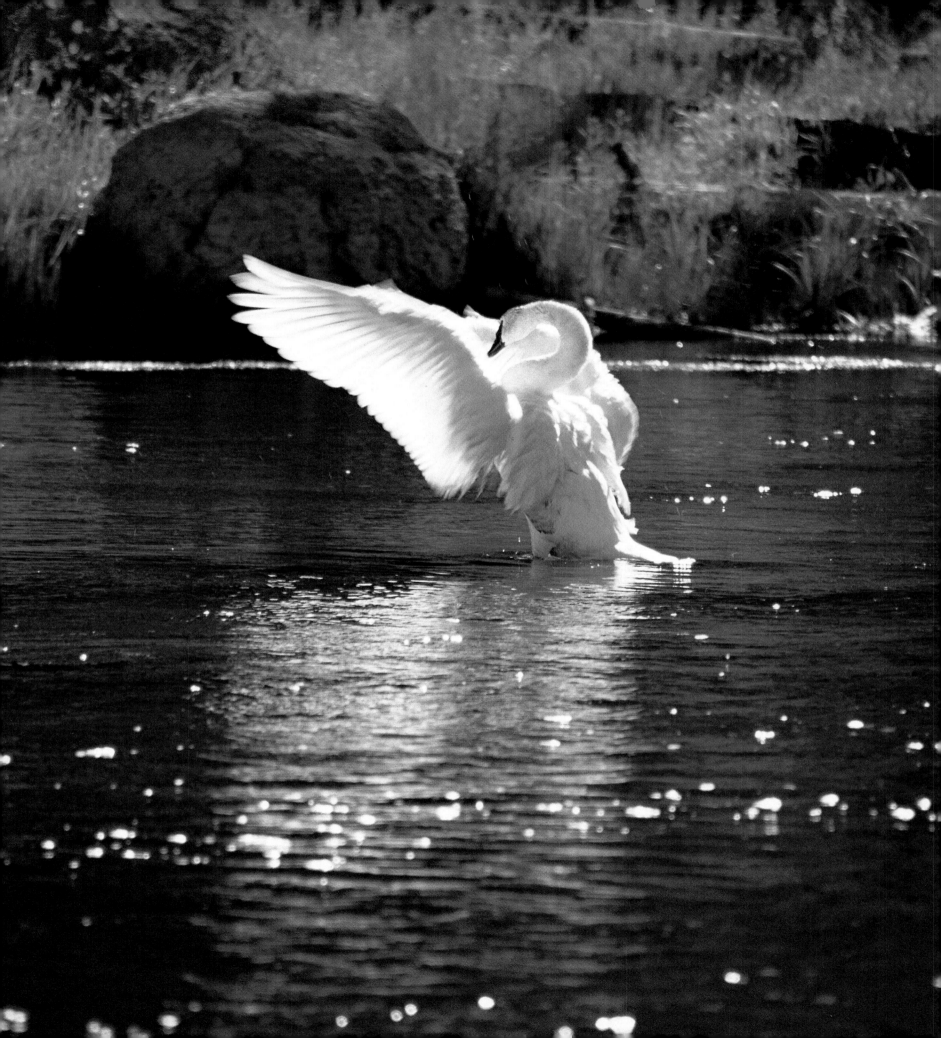

digging extra dens in case one is disrupted and they have to move quickly.

A second group is made up of bachelors: single, unaffiliated coyotes who are young or physically incapacitated and have no fixed territory, family, or home. They often hunt and feed alone and represent the pool from which new mates are chosen.

A large, transient pack forms a third group that comes together in the winter. Consisting of two to twenty-two members, this group includes winter migrants or nomadics who feed together on carcasses and cross territorial boundaries with no fixed range of their own. In spring, they disband and go their separate ways.

Finally, there is the resident pack that forms a "coyote kibbutz." These animals live communally. Two or three pairs den together, raising their separate litters as one. Pups are nursed by any of the females, and food, brought by the males, is shared. Coyote demographics are also wisely controlled. In a year when food supply is diminished, litter sizes go down. And it's thought that the number and frequency of howls can stimulate or slow down reproduction.

A trumpeter swan rises from the surface of a pond. Swans need a long waterway for takeoff and can be trapped by ice when ponds freeze suddenly in the fall. The swan will wait patiently for the sun to melt the ice, and then, if possible, depart.

Yellowstone National Park is a laboratory in which biologists study every living thing, from the honey bees who became confused during the 1988 fires to river otters, wolverines, foxes, cougars, bears, fish, and aquatic bugs. It's full of fascinating thermophilic life found at the park's hot springs—bacteria that can survive in water between 122 and 140 degrees Fahrenheit and a carnivorous fly, the dolichopodid, that eats the larvae of other hot-spring-loving flies.

In one afternoon, sitting by an unnamed stream somewhere midpark, I watched a redtail hawk carrying a mouse high above my head, saw a peregrine falcon pick off a swallow, observed a coyote eat a vole, and spied a marten picking at a red squirrel in a tree. Nowhere is the interdependency between all organisms in an ecosystem so evident, so easy to see as in this park. And while we glamorize the big, legendary mammals, we forget that there is a huge population of smaller beings who sustain much of that life and have unique natural histories of their own.

Because the Wyoming skies are so open to view, birds become a predominant interest to those who live here. In spring, Yellowstone National Park is part of the Rocky Mountain flyway for migrating birds. Migration is one of the most studied aspects of ornithology and one of the least understood because it involves so many variables: the length of light in a day, celestial navigation, cyclonic storms, and the sensing of magnetic fields.

Peregrine falcons arrive in the first week of April. There are ten pairs in the park, and there's room for many more. In May come the bald eagles and ospreys. Since the fires, eagles are in a transition phase. The burnt trees in which they chose to build nests have fallen down, felled by wind, and it is difficult for them to find trees big enough for their nests. On the other hand, ospreys have flourished, with ninety-one nests scattered along the rivers of the park.

In June, trumpeter swans are counted and monitored, and in July, everything happens. Loons, swans, falcons, white pelicans, sandhill cranes, Caspian terns, doubled-crested cormorants, songbirds, migrating shorebirds, and ducks all come through. Mornings are a symphony of birdsong, and the sky is filled with every kind of wing shape and activity.

By August, things settle down, and by September, the birds that passed through on their way to the Yukon and Alaskan arctic begin to come back, especially the songbirds and shorebirds. In October, the migrant trumpeter swans leave the park, and in mid-November snow geese come in small flocks, make a brief stay, then move on. By mid-December much of the waterfowl have gone, though some ducks, Canada geese, and a few swans remain.

Ravens, bald eagles, boreal owls, Canada jays, chickadees, finches, and magpies also spend the winter in the park. Snow muffles all sound. The park rests. Sometimes swans get stuck in small, frozen ponds. There is not enough room to get out and take flight, and that's when the coyotes have a field day, predating on them.

Then the booming reports of lake ice announce spring. It is the small mammals who seem to venture out first. And there are so many of them.

Voles, pocket gophers, marmots, rabbits, mice, bats, squirrels, beavers, chipmunks, minks, martens, weasels, badgers, river otters, muskrats, pikas, and wolverines—these are the small ones who eat and are eaten, who build beautiful houses, whose burrowings aerate the soil, and who consume and redistribute seeds and fungal spores. Each animal fills its vital niche in the great web of lives.

In the summer there is so much animal activity in the park that there is never any real silence. In late summer, above nine thousand feet, I've watched pika—a small, tailless member of the rabbit family—scrambling across talus slopes, harvesting grass, and piling it into haystacks in the cracks between large boulders. Their whistles are only a bit softer than the sharp ones of the yellow-bellied marmot, an animal that early explorers called "the whistle pig." Related to squirrels, but much larger, lazier, and fatter, marmots live in large colonies and hibernate jointly at least eight months of the year. Even in their active summer months, they feed only in the morning and late afternoon and rest during the middle part of the day.

Down in the ponds, beavers build their domed palaces, cantilevered over running water. Made of tree branches, they have underwater entrances and sleeping platforms inside the lodge. By damming ponds, beavers improve the habitat for voles, birds, moose, elk, and deer.

Muskrats swim by with mouthfuls of duckweed, sedges, bullrushes, cattails, or pond lilies. Their lips seal behind their incisors so that they don't also gulp water when harvesting these aquatic plants. In winter their food is stored between cracks in the ice. So adapted are they to aquatic living that they can swim a distance of one hundred and eighty feet without surfacing for air and, if necessary, stay underwater for twenty minutes. Muskrats are also fine architects, building conical houses with separate rooms for sleeping and eating

The gray wolf has been missing from the Greater Yellowstone Ecosystem since the early part of the century, when an all-out war was waged against wolves and other predators. In 1994 Congress approved plans to reintroduce the wolf to Yellowstone National Park.

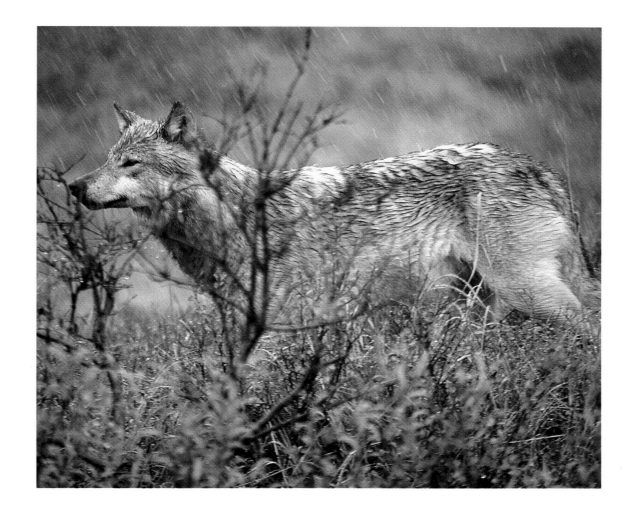

FOLLOWING PAGES:

The park's grizzly bears live in the Hayden Valley and the Central Plateau. There are about two hundred grizzlies roaming the high country in summer. In spring, they inhabit the lower feeding grounds of the park's river valleys. Fast-moving and dangerous, these large animals—which often weigh six hundred pounds or more—rarely come into contact with human visitors.

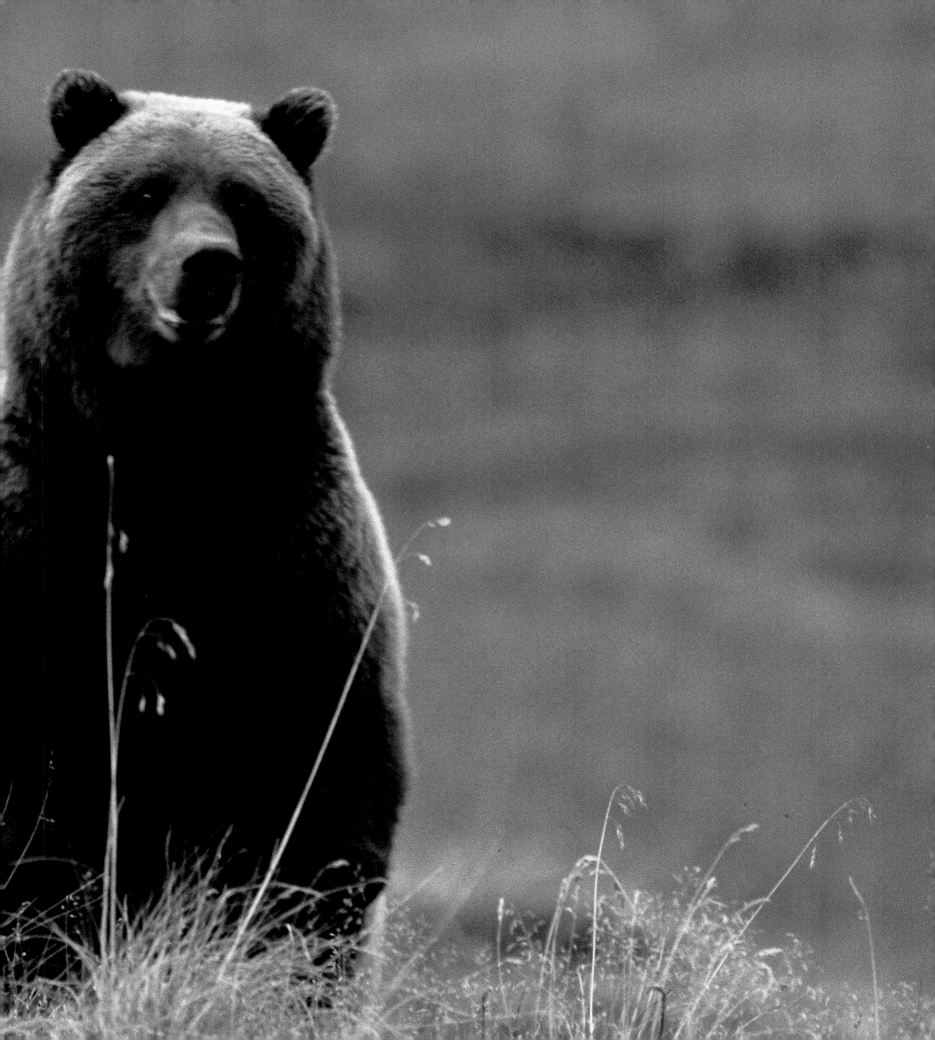

and, like beaver lodges, with underwater entryways.

Ermines, weasels, minks, and the rare wolverines slink around the park eating mice. And the mice seem to make the world go round.

Deer mice, for example, are found everywhere in the park, from the thermal flats to the tops of mountains. Capable of breeding in every month of the year—though they slow down in winter—they bear up to nine babies per litter. The young grow fur and teeth in the first week of life, are weaned in the fourth week, and are sexually mature by the eighth week. Just one pair of mice can produce nearly four hundred babies per year. If it weren't for the fact that so many animals like to eat mice, the park's deer mouse population alone (and there are eight other species) would quickly outnumber that of any other animal.

Some animals are present but rarely seen in the park—the elusive mountain lion, the bobcat, and the lynx. There are fifteen to twenty resident cougars in the northern part of the park. But one animal is missing—the wolf. A wildlife biologist at park headquarters in Mammoth assured me that a sighting may soon be possible. After years of heated debate, approval was given in Congress to reintroduce wolves into the park. The animals were trapped in Alberta and British Columbia, transported to one site in Idaho and two sites in the park, and released with radio collars on.

No one can predict how far they'll range, whether they'll go back to Canada or stay in Idaho, Wyoming, and Yellowstone National Park. While the presence of wolves will help restore balance to the park's ecosystem, one element is still missing: the human as predator. The neolithic days of hunting and gathering are over on this continent, and no one knows exactly how to replicate the predator-prey relationship in the protected wilderness of America.

River otters, sleek and lithe, can be seen in the part of the Yellowstone River that flows through the Hayden Valley. Shy and semiaquatic, they can also be spotted playing on the shore of Yellowstone Lake, along the Gibbon River, and in the shallow water of Yellowstone's streams.

BIOTIC COMMUNITIES—
THE DIVERSITY OF LIFE

Like every habitat in Yellowstone National Park, Soda Butte Creek in the Lamar Valley is surrounded by a tightly interwoven community of plant and animal life. Mountains, meadows, streams, grasses, trees, wildflowers, and shrubs help determine the animals, fish, birds, and insects that are found there, and the animals affect the variety and distribution of the plants.

Looking across the valley on a summer morning, I heard the howls of two coyotes padding through dew-studded grass. A raven flew ahead of the pair, leading them to a winter-killed carcass which they all shared. And songbirds and swallows ate their fill of bugs that gathered at the feast.

Nearby, elk, mule deer, and bison grazed on Idaho fescue, bluebunch wheatgrass, and the black-topped sedge grass that grows along Soda Butte Creek. The stream slides out of high mountains to the east, all over ten thousand feet high—Barronette Peak, Abiathar Peak, and The Thunderer. In places where the stream slows, reeds and lilypads grow, and ducks drop down to spend the summer in private sanctuaries, hatching and raising their young. Native cutthroat and brown trout live in these shallow waters, spawning on the gravely bottom, disturbed only by the occasional swipe of a bear's paw.

This is prime grizzly country. The northeastern part of the park is steep and

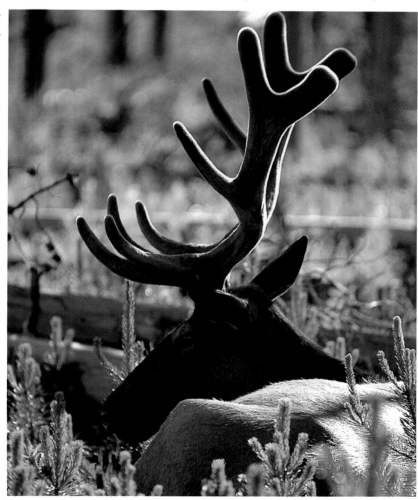

A bull elk in velvet rests in a lodgepole pine forest. Elk seek the protected, shady slopes of the backcountry in summer. At dawn and dusk, they come out into grassy meadows to graze on their favorite foods— grasses, sedges, and herbs.

Bison have their calves in April, and by June, they have shed most of their shaggy winter coats. They graze the wide open meadows of the park and, like elk, prefer a diet of grasses, sedges, and herbs.

remote, with long, narrow valleys and rugged, mountainous terrain.

In midsummer, the meadows are carpeted with wildflowers of every color, and by August, snowberries, serviceberries, and thimbleberries have ripened—a feast for both bears and birds.

Bordering the meadows are forests of lodgepole pine and, at higher elevations, subalpine fir, Engelmann spruce, and whitebark pine, whose nuts grizzlies adore. Interspersed among the evergreens are outcrops of aspen that glow like golden torches in the fall. Overhead soar red-tailed and Swainson's hawks and golden eagles. And above treeline, on nearly vertical cliffs, bighorn sheep jump from ledge to ledge with perfect grace.

To understand a place and what lives there, it is sometimes best to get down on your hands and knees. One morning in the meadow I discovered the ground nests of western meadowlarks whose operatic voices fill the Wyoming air with song. Closer to the forest, I saw chipmunks, mounded squirrel caches which black bears love to raid, mouse and vole tracks, and the scats of foxes and coyotes. There are also some elusive animals I knew were here, but couldn't see—the mountain lion, the cougar, and the lynx.

The great gray owl is the largest owl in North America, with a five-foot wingspan and a tail that is twelve inches long. It lives in timbered areas with meadows nearby. Unlike other owls, who are nocturnal hunters, great grays are most likely to catch their prey—voles, mice, and pocket gophers—in the early morning or afternoon.

Bighorn sheep graze the high alpine meadows near steep cliffs. Their jumping and balancing skills are legendary. Until autumn, rams and ewes live in separate bands and can sometimes be seen in the Mt. Washburn area.

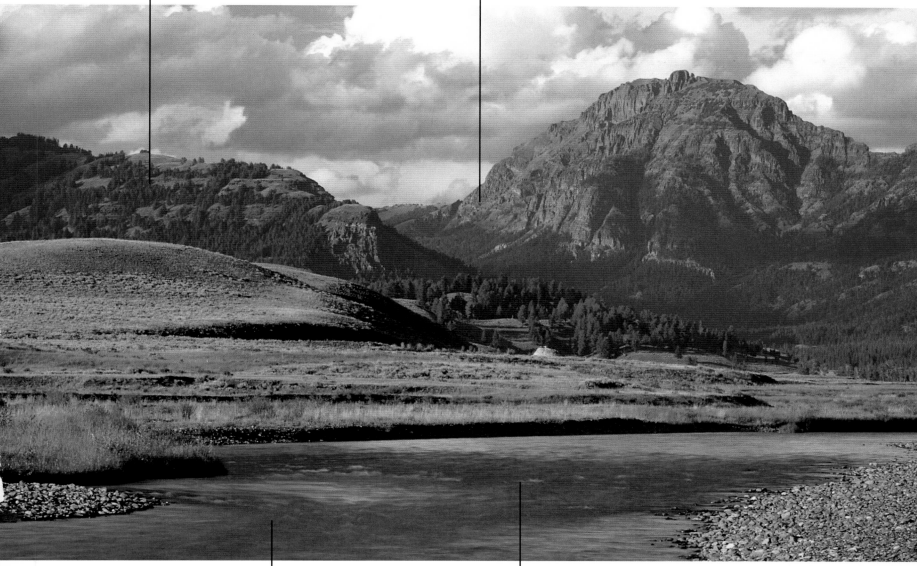

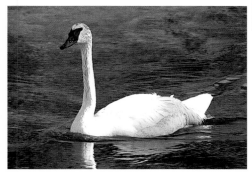

Trumpeter swans are the largest waterfowl in North America. Pure white with a black beak, they glide the ponds and rivers eating aquatic plants and seeds. Some of Yellowstone's swans are year-round residents, seeking out warm springs and sheltered bays during the worst of the winter weather.

Trout are found in Yellowstone's rushing mountain streams. The fish spawn in early June, depositing their eggs in small depressions in the stream's gravel.

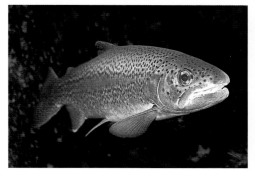

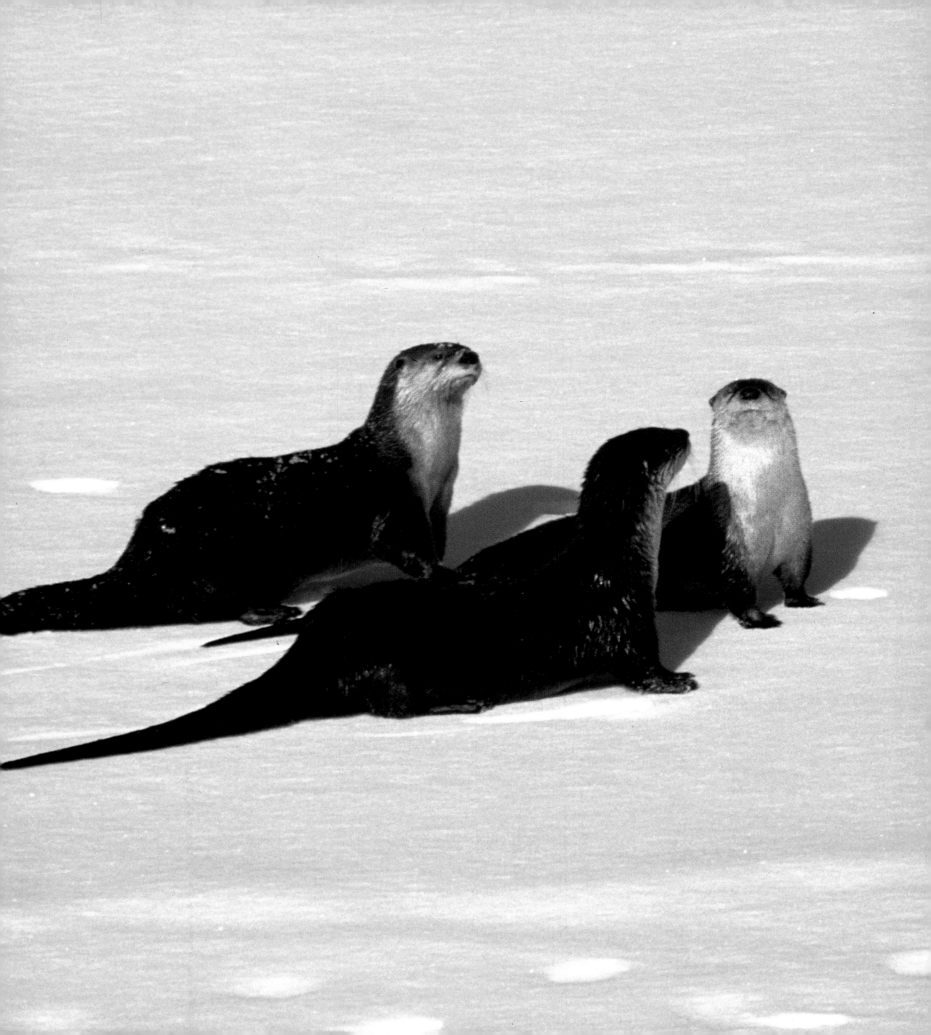

The long-legged moose stands in ponds and rivers to feed on willows and other riparian plants.

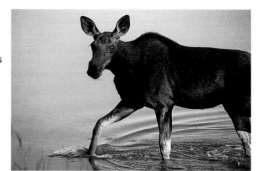

Unita ground squirrels live in sagebrush and mountain meadows up to eleven thousand feet. These rodents, sometimes called "picket pins," spend six to seven months in hibernation and live on a diet of grasses, forbs, and mushrooms, as well as insects and carrion.

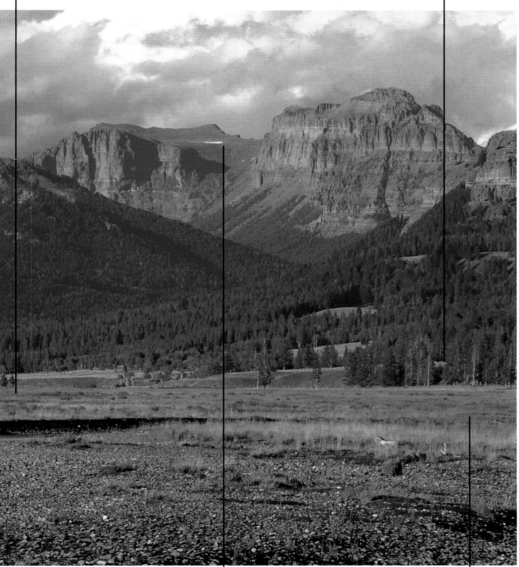

The bald eagle is white-headed, with an eight-foot wing spread, a black body, and a white tail. Its nests are flat platforms made of tree branches and twigs built on cliffs or in tall trees, often overlooking water.

The pronghorn, or antelope, likes the wide-open spaces of the northern range of Yellowstone National Park in summer. In November, pronghorns head southeast through the Gros Ventre Mountains to winter near the high desert of Farson, Wyoming. Born for speed, pronghorns can run sixty miles an hour.

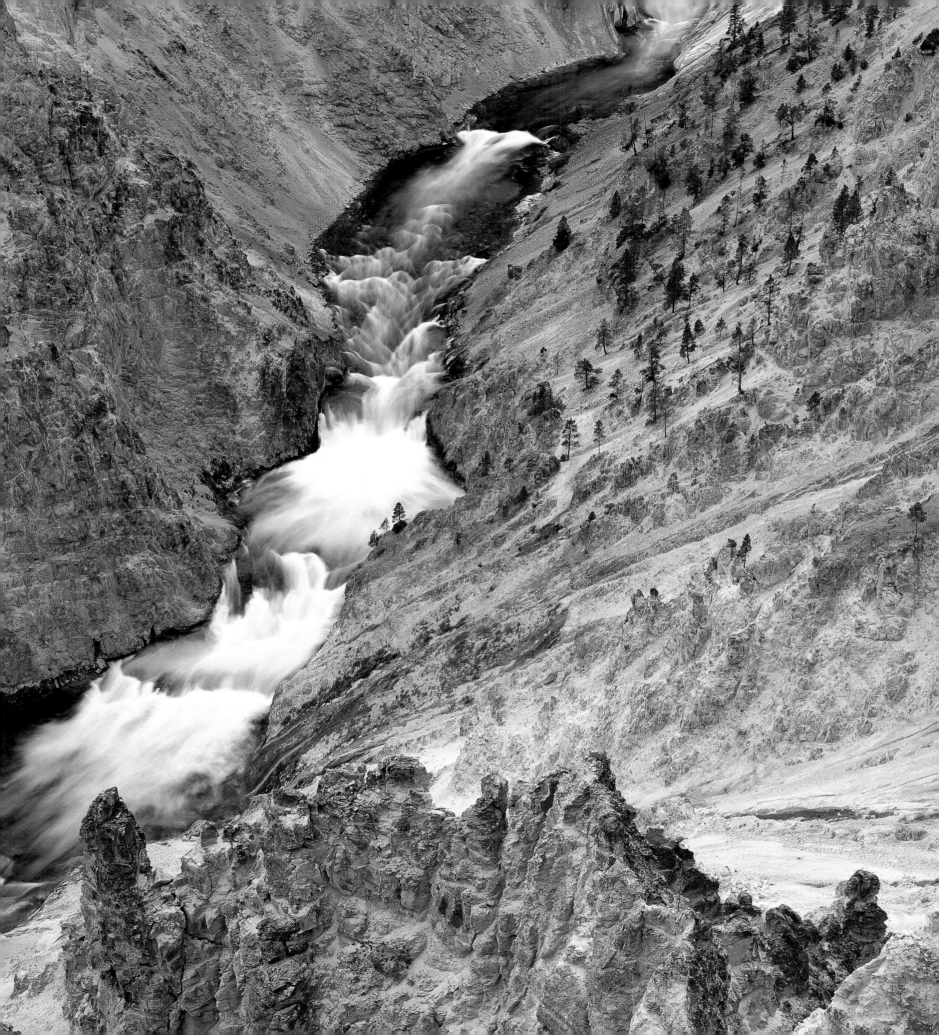

Near the end of August, I drove the length of the greater Yellowstone from Hoback Junction, Wyoming, to Bozeman, Montana. Lodgepole pine shadows strobed the road. In the Tetons, even though it was hot, the aspens had already started to turn, as if the bunched yellow blossoms of rabbit brush down low had crept upward into the trees. A stilt-legged baby moose leaned against her mother, and together they drank from a stream. Ospreys cruised oxbows, their primordial wingspans driving black crosses over the land.

In late August, red squirrels were busy caching pine cones and seeds for winter use. Bears were stealing those caches, or else eating fish and berries. Pikas were still cutting haystacks, and pronghorn bucks were vying with other males for harems—female antelopes with whom they would breed.

Often by that time of year there has been a snow, or at least a hard frost. Now there was no snow—only smoke from wildfires raging in the forests of Idaho and Montana, as well as a small one near Pelican Creek in the park. Walking out on a long spur of gravel in Yellowstone Lake, I heard water lapping loudly on black sand beaches. Smoke from the forest fires rose as if from the belly of the dormant volcano, then mixed with a pine wind wafting down from high mountains, bringing a taste of the coolness to come.

In darkness before dawn the next day, I drove from Gardiner to Blacktail Ponds, small ovals of water strung together by streams that seep through bullrush. I walked for a

*R*ushing white
cataracts of the
Yellowstone River
viewed from
Inspiration Point in
the Grand Canyon
of the Yellowstone.

WALKING THE RIM

while, then sat on a hill and watched. If you stay at any pond long enough, you will see things; wildlife will come.

The sun rose blood red in smoke, and white steam from the water drifted east to meet the light. Ducks—mallards—and several pairs of coots quacked, fluttered, and called out a warning. A pair of coyotes sauntered by the far edge, sniffing for mice, marking territory on a broken tree branch, then a rock. The large male sat facing east and, joined by his mate, lay curled against sagebrush to warm up in the sun.

Nothing dramatic happened that morning. The ducks swam peacefully, eating aquatic bugs and weeds, and the coyotes, after their short respite, trotted to the top of a hill, howled once, then moved on.

In 1885, the naturalist John Muir was asked to visit Yellowstone and write about the park. He said: "A thousand Yellowstone wonders are calling, 'Look up and down and round you!' And a multitude of still, small voices may be heard directing you to look through all this transient, shifting show of things called 'substantial' into the truly substantial, spiritual world whose forms flesh and wood, rock and water, air and sunshine, only veil and conceal, and to learn that here is heaven and the dwelling-place of the angels."

Thunderhead clouds are reflected by the mirrorlike surface of Floating Island Lake in the Blacktail Plateau.

Every backcountry trail in Yellowstone National Park offers a unique vista, and the more you dive into the deep country, the easier it is to see how the ecosystem hangs together. The Mary Mountain Trail through the Hayden Valley follows Alum Creek and Nez Perce Creek from the Yellowstone River all the way to the Lower Geyser Basin and passes through prime grizzly habitat; the Howard Eaton Trail follows the wide and peaceful Yellowstone River as it flows north from Fishing Bridge to the Grand Canyon of the Yellowstone. The Heart Lake Trail links three large and exquisite backcountry lakes: Heart Lake, Lewis Lake, and Shoshone Lake. In a year when there are no fires and visibility is good, you can walk up Mount Washburn and see in every direction. You can hike through bogs where moose feast on willows, through burns alive with birds, across rolling sagebrush hills with ravens, eagles, coyotes, and elk, down into river valleys, into the intricate mountain fortresses of Mount Holmes, the Trident, or the Needle. You can saunter across steaming geyser basins pooling azure and pink waters and paved with gray sinter deposits. Whole summers could be taken up, walking every trail.

Eating lunch on the banks of the Yellowstone River, I watched a mallard duck guide her young ones—seven ducklings—across the water. The river drains north from Yellowstone Lake at Fishing Bridge and glides in a smooth, majestic flow. Where the current was brisk, she pushed them from behind like a tugboat, but nearer to shore where the current slowed up, she led them between green mats of pondweed, floating islands that hid them from view as they glided downstream. Once, they stopped at a half-submerged log and warmed

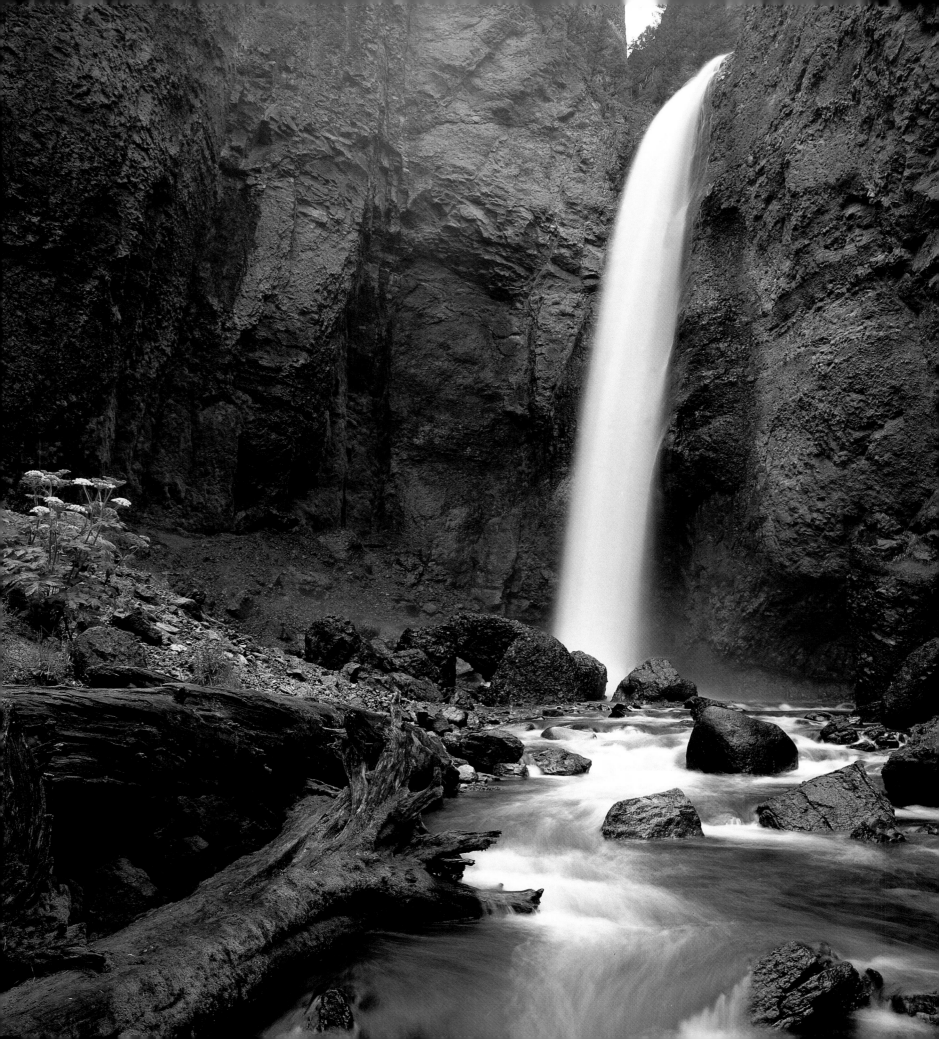

themselves in the sun. A Swainson's hawk wheeled by, giving its six-whistle cry. One by one, the ducklings slid back into the water and were taken fast by the current.

Where were they going? I wondered. Would they fly back this way later in the day? Where did they live, and where would they go this fall? Downriver, they paddled past twelve Canada geese basking on a sandy bank and disappeared from view.

At every edge of the park there are beautiful rivers: the Lamar and the Firehole River—filling with Old Faithful's hot water, then emptying it out. I like to call the Gibbon River the Ribbon River where it slows and undulates like a narrow band of silk, and each bend is home to a swan.

The Grand Canyon of the Yellowstone is located in the north-central part of the park. Bending to the east, the river suddenly drops, and the cool glass of the Yellowstone River "breaks into foam-bloom," as John Muir said. There are two spectacular falls: the Upper Falls, which is 109 feet high, and the Lower, which is 308. At the turnout called Brink of the Upper Falls, the power of rushing water is so immense—during high water in June, 63,500 gallons a second flow by—that you can't think or hear.

Downstream from the Grand Canyon of the Yellowstone is Tower Fall, a thin strand of water tumbling over a vertical cliff.

One of the first humans to record his impression of the Grand Canyon of the Yellowstone was Nathaniel Pitt Langford, a member of the 1870 Washburn expedition. In his flamboyant and breathless prose he wrote: "Until within half a mile of the brink of the fall the river is peaceful and unbroken by a ripple. Suddenly, as if aware of impending danger, it becomes lashed into foam, circled with eddies, and soon leaps into fearful rapids. The rocky jaws confining it gradually converge as it approaches the edge of the fall, bending its course by their projections, and apparently crowding back the water, which struggles and leaps against their bases, warring with its bounds in the impatience of restraint, and madly leaping from its confines, a liquid emerald wreathed with foam into the abyss beneath."

From Artist Point, I walked the rim of the canyon. A thousand feet deep and quite narrow, the canyon walls are bare cliffs of hard rhyolite which, at sunrise, are all burning color: cinnamon, vermillion, rose, red, and gold. John Muir wrote: "All the earth hereabouts seems to be paint."

Weathered, eroded, and silica-rich, these walls are the decomposed remains of viscous lava flows from one of the many Yellowstone eruptions. Weakened by thermal water and hot gases, the rhyolite gave way as water flowed over its steep edge. Here, the river worked like a sword, cutting a channel down through the layered sides of an ancient volcano—a river of silt and water slicing into and flowing over a river of fire.

Far below, white cataracts swept by bright cliffs. Across one impossibly steep swath of red earth, elk tracks traversed a soft wall, angling down toward a spring, never returning. On the north-facing slopes, which are cooler, hoodoos and rock pinnacles are the

homes for single trees—bent pines whose roots leg back toward safety, drilling down into the crack of a rock for water. Here and there, rocks dam water into delicious pools, then, roiling and spinning, let it go again. Without binoculars, the river below is a blue thread.

In 1871 Thomas Moran painted a series of watercolors from this trail, as well as from the trail that follows the north side of the canyon, with lookouts on one side at Inspiration Point and on the other at Sublime Point. Moran was a member of the 1871 Hayden Expedition, which helped put the great Yellowstone on the map. His watercolors have a transparency of color: the blues and violets of the river are limpid, and the pinks, yellows, and whites of the exposed cliffs are bright. When he died at the age of eighty-two in his East Hampton, Long Island, home, an unfinished canvas of Tower Fall was found on his easel.

Less than half a mile down-canyon, the trail veered off to the south. A red fox spooked out of the timber, and red squirrels chattered over my head as if to send me away. I crossed a bog on a wooden footbridge, the roar of the falls still in my ears. Nestled in the green quiet of pines, the trail brought me to Lilypad Lake. Broad, heart-shaped leaves caught sunlight and tipped up bright as mirrors as a breeze blew through. Blunt-nosed dragonflies flitted through the green maze, and two families of mallards swam with their young.

Continuing on to Clear Lake, I climbed a rise and smelled sulfur. All vegetation stopped, and I walked the thermal ground past steaming vents and a fifteen-foot-wide mudpot whose yellow broth looked like a witches' brew. Farther up the hill, mushpots and brothpots burped and hissed. One fumarole sounded like a torch being ignited. A few tiny plants with pinhead-sized white flowers fluttered above bare, gray ground.

Clear Lake is small and looks like a three-pointed hat and isn't clear at all, but rather an opaque green. Hot water bubbled up at the eastern end, and all around elk tracks pressed deep into mud. On the other side, downed pines lay across the shore pointing inward at the water. Migrant shorebirds—sandpipers—searched the lake's edge for food.

Up the hill, the country rolled out in sagegrass meadows. Elk shaded up under spruce and fir trees, their chins tipped up haughtily as I passed, but unmoving. I could see the last vestige of what had been endless meadows of wildflowers: bluebells and harebells, yarrow and purple asters. As I walked toward Wapiti Lake, a young woman passed me. "Where are you going?" I asked. "To work," she replied jauntily. "I'm a waitress at Fishing Bridge," which was twelve miles away.

As I walked, I swallowed smoke. White clouds of it billowed from the fire near Pelican Creek. A "camp robber"—a Clark's nutcracker bird—followed me. Looking south I could see the northern end of Hayden Valley—a lost lake, with its arms and inlets now grassy meadows full of bison, elk, and deer.

*S*edge and native bunch grass in the Lamar Valley are sun-cured, protein-rich food for the elk, deer, and bison that graze here in preparation for the hard winter ahead.

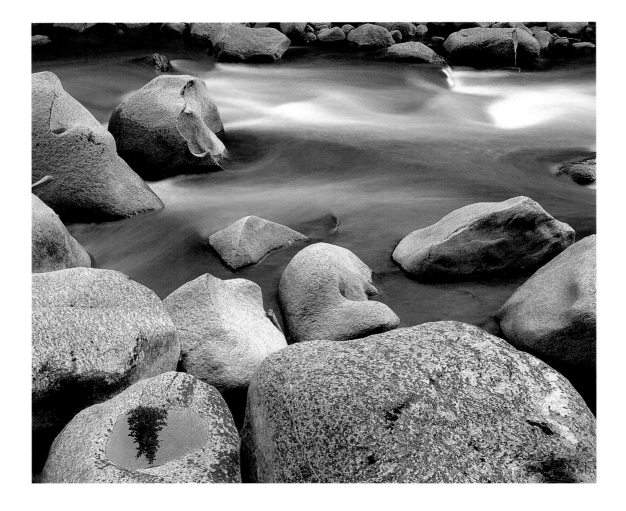

S*tream-carved rocks*

in the Lamar River.

Later I turned back and followed the trail to Ribbon Lake. In rust-colored water I saw fish jump at hatches of bugs, then found the rim of the canyon again and gazed down at Silver Cord Cascade. Several trails go all the way down into the canyon, but the climb back up in the afternoon heat can be hard.

At the end of the day I found myself teetering over the edge of the Grand Canyon. I lay on a promontory of rock peering straight down past shallow caves and pine sentinels to rapids breaking over rocks and boiling chasms a thousand feet below. Soon it would be winter. It is known that one bear makes her den on the vertiginous slope that flanks the lower falls and sleeps to the sound of water. By January the falls are covered with a sheath of ice like a mask, but behind, water—now reduced to five thousand gallons per second—breaks over rock in its tangled journey to the sea.

On my way home at dusk I sat by Blacktail Ponds again. There was no steam rising. Instead, the waters were filled with squabbling ducks. A small herd of antelope grazed the fawn-colored hill above the ponds, and as I walked down by a reed-filled bog, a pair of sandhill cranes flew up, honking their single notes alternately—one high, one low, wings undulating. Landing not far away, the color of their bodies blended into sun-cured grass.

FOLLOWING PAGES:

Ledge Geyser in Porcelain Basin erupts, sending sprays of steam and water high into the crisp Wyoming air.

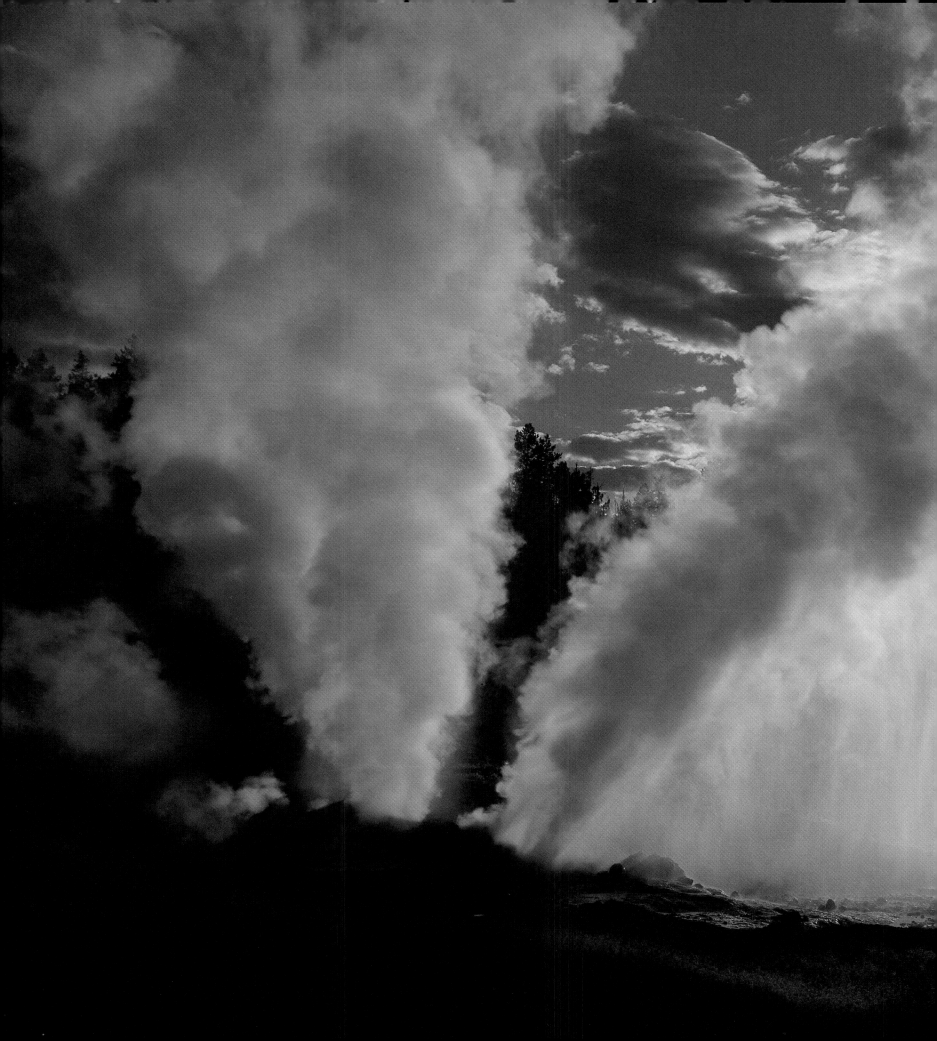

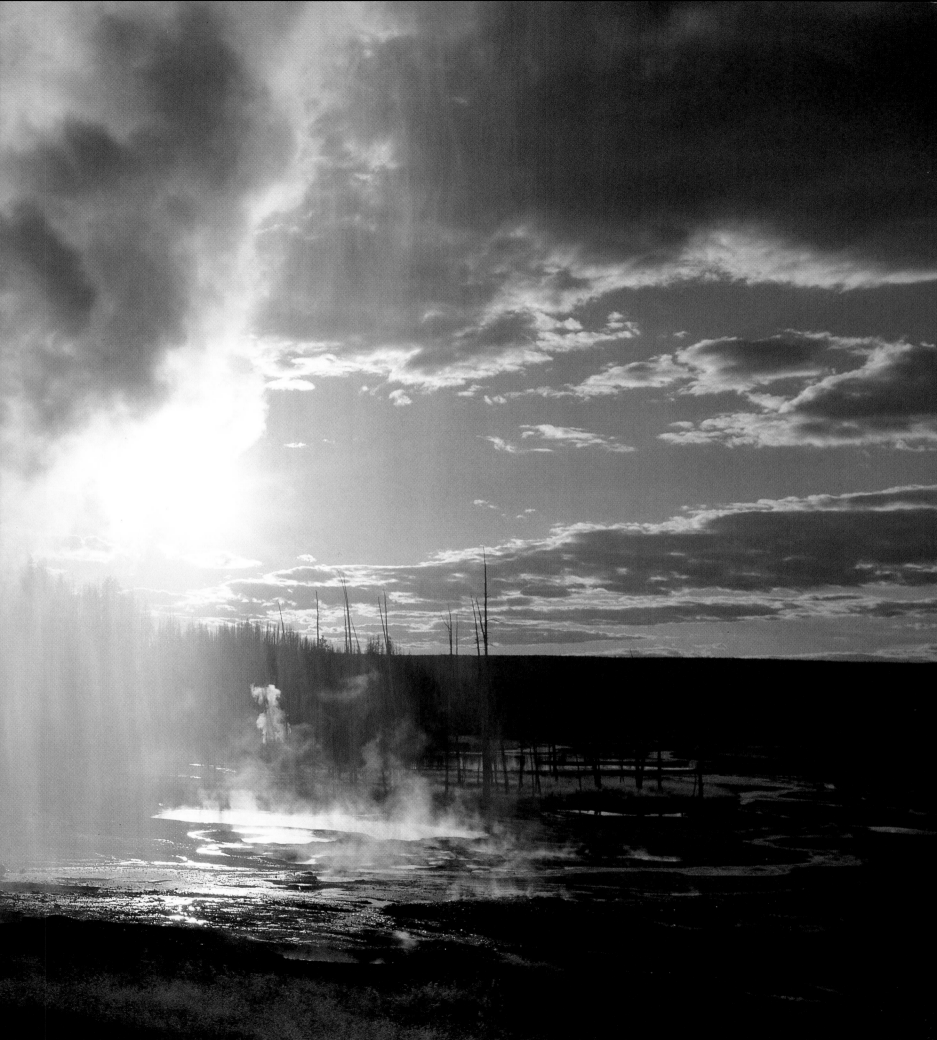

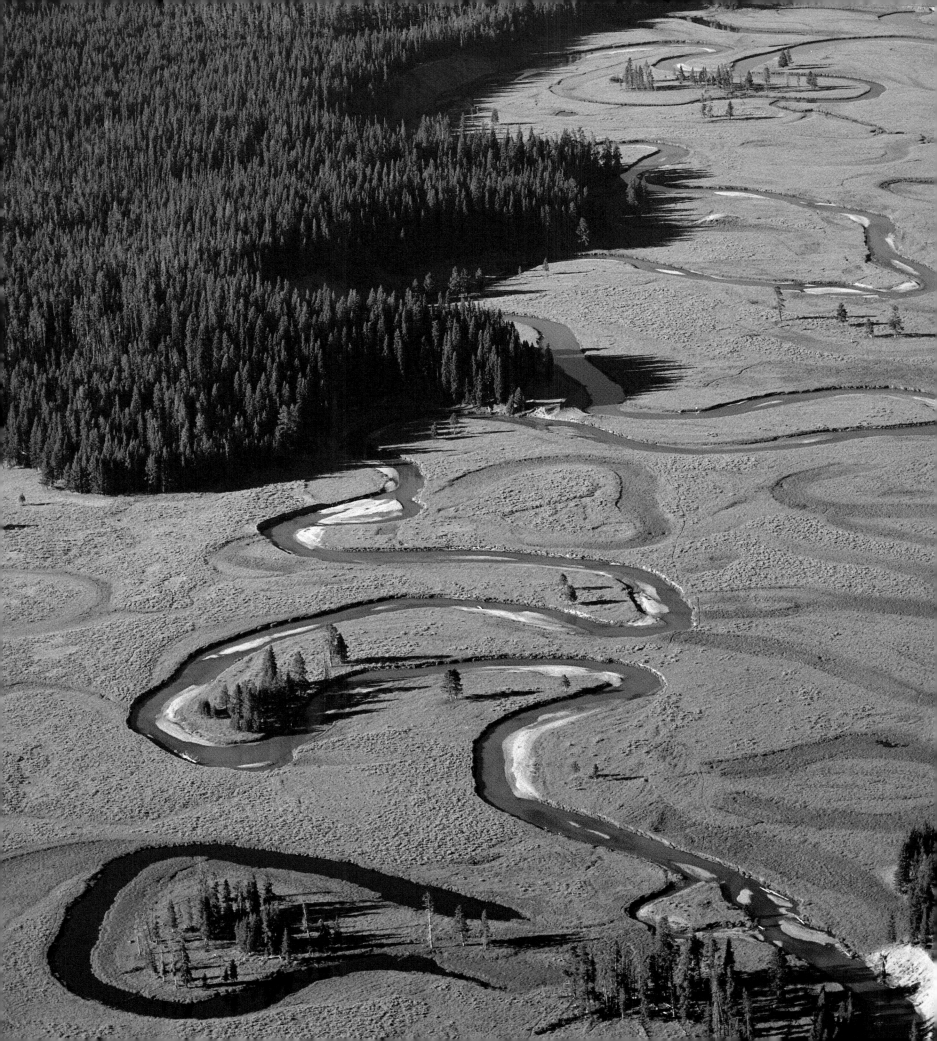

THE MEANDERING YELLOWSTONE RIVER

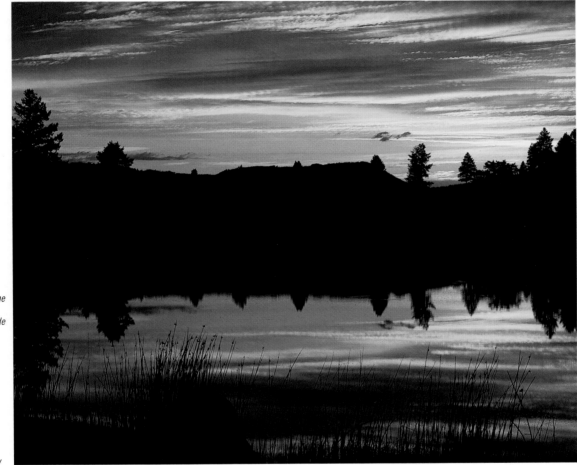

As the Yellowstone River proceeds north from Yellowstone Lake, it passes through the wide Hayden Valley in a series of winding curves. The word meander comes from the Latin word, maender, which means "to wander." The current of a meandering river is shunted by centrifugal force from one side of a bank, called a point bar, to another, called a cutbank, and back again. Where the current crosses from one side to the other, shallow shoals and gravel bars often appear. The Yellowstone River's graceful meanders provide peaceful feeding grounds and refuges for visiting ducks, trumpeter swans, and white pelicans.

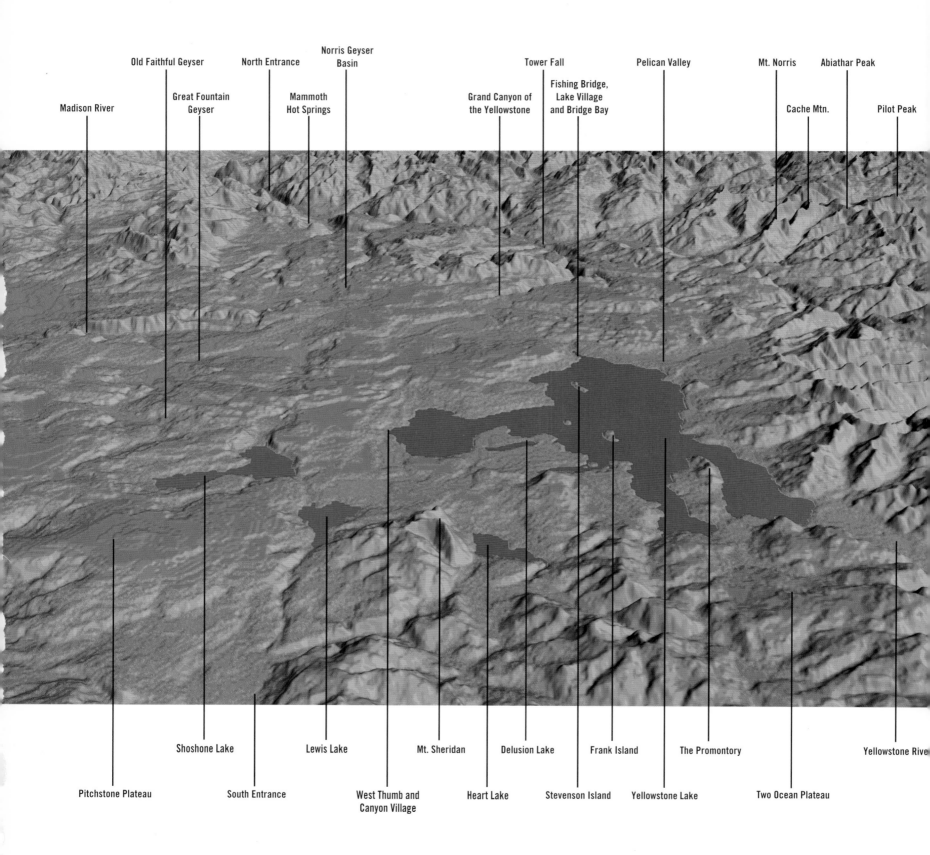

Madison River

Old Faithful Geyser

North Entrance

Norris Geyser
Basin

Great Fountain
Geyser

Mammoth
Hot Springs

Grand Canyon of
the Yellowstone

Tower Fall

Fishing Bridge,
Lake Village
and Bridge Bay

Pelican Valley

Mt. Norris

Cache Mtn.

Abiathar Peak

Pilot Peak

Pitchstone Plateau

Shoshone Lake

South Entrance

Lewis Lake

West Thumb and
Canyon Village

Mt. Sheridan

Heart Lake

Delusion Lake

Stevenson Island

Frank Island

Yellowstone Lake

The Promontory

Two Ocean Plateau

Yellowstone River

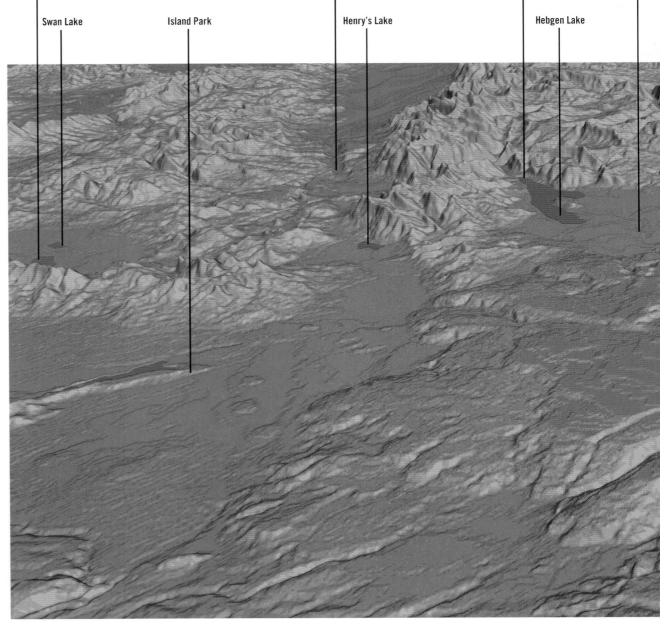

Upper Red Rock Lake

Swan Lake

Island Park

Hutchins Ranch

Henry's Lake

Hebgen Dam

Hebgen Lake

West Entranc

lakebed, and its grassy hills are dotted with herds of bison. Trumpeter swans and white pelicans glide across the river's slow-moving water, and rafts of visiting ducks and Canada geese feed in its gentle eddies.

The Yellowstone River crosses the caldera rim at Fishing Bridge. Wide and glassy, the river flows north, then bends abruptly and drops thousands of feet into the Grand Canyon of the Yellowstone. The canyon was formed as this strong surge of water cut through volcanic, rhyolitic rock that had been softened by gases and hot water. The yellows and oranges in the walls of the canyon are the exposed iron oxides in the rhyolite. The canyon is narrow, but its walls are thousands of feet high. Cataracts of water drop through two falls, the Upper and Lower. The river then continues north through the Yellowstone's shaded Black Canyon and on into

Montana through the Paradise Valley, until it bends east at the town of Livingston.

The western part of Yellowstone is the park's geological hot spot. Old Faithful erupts at seventy-six-minute intervals, spewing volcanically heated water one hundred fifty feet

into the air. To the north, toward Madison and Norris Junction, are the spectacles of sounds and colors in Sunset Lake, Emerald Pool, Grand Prismatic Spring, Fountain Paint Pots, and Porcelain Basin, the hottest spot in Yellowstone National Park. Steamboat Geyser in the Norris

TOPOGRAPHY OF YELLOWSTONE

The center of Yellowstone National Park is a forty-five-mile-wide caldera—a large, basin-shaped depression formed by the inward collapse of a volcano after its eruption. As the volcano's interior chamber rapidly expelled magma, its roof collapsed and was swallowed by new, rising magma, which then spread out across the land as lava flows. Mountain valleys were filled by these thick, volcanic deposits, which formed what are now the plateaus of the park.

Looking at a side-view elevation of the Yellowstone, it is easy to see the collapsed volcanic chamber, now partly filled with lake water; the high, wide plateaus of hardened lava and ash; and the surrounding amphitheater of mountains—the Gallatins, Absarokas, and Tetons.

The rim of Yellowstone's caldera passes just below Mount Washburn, one of the park's dormant volcanos, then moves through the Pelican Valley, crosses Yellowstone Lake, and travels north of Mount Sheridan and along the southern edge of Lewis Lake. It then spills out into the Shoshone Geyser Basin, west of Old Faithful, following the Madison and Gibbon Rivers across the Central Plateau. It passes Ice, Wolf, Grebe, and Cascade Lakes until it has come full circle at the foot of Mount Washburn.

Yellowstone Lake is the deep pool at the eastern edge of the caldera, and the Central, Madison, and Pitchstone Plateaus spread out to the west. The largest mountain lake in North America, Yellowstone Lake is twenty miles long and fourteen miles wide, with a depth of three hundred twenty feet at its deepest point. It is home to native trout, who like its cold waters—an average of 60 degrees at the surface and 40 degrees at the lake bottom.

The Hayden Valley, just north of Yellowstone Lake, was named after the famous geologist, Ferdinand Hayden, whose 1871 expedition into the park helped persuade Congress to pass the National Park Bill. The Yellowstone River meanders across this wide, treeless valley, formerly a

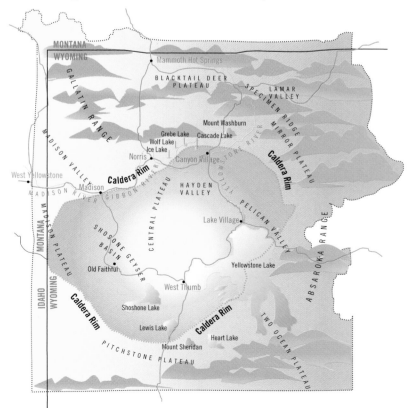

Entrance Trout Peak

Fortress Mtn. Wapiti

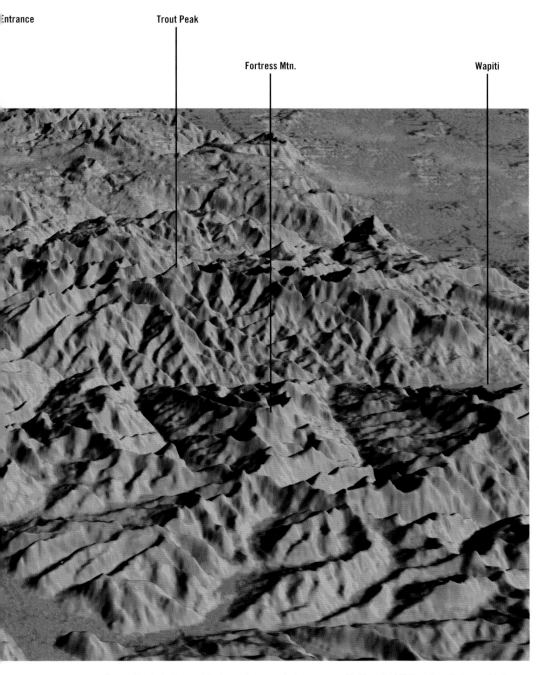

Down near the southern boundary of the park, the long fingers of Yellowstone Lake rest against Two Ocean Plateau. Across this spine the Continental Divide wriggles, sending stream water to both sides of the continent and to both the Pacific and Atlantic Oceans.

NOTE: Although it may look like a photograph, this image is actually a computerized, extruded, topographic view. It was created using digital elevation models derived from the United States Geological Survey (USGS) satellite maps and traditional, flat USGS topography maps.

To prepare the extruded topo map, data from the USGS was downloaded from the Earth Science Information Center to a personal computer and converted into a three-dimensional model. There, a flat or "birds-eye" version was rendered which simulates a direct overhead view of the region (the end sheets on both inside covers of this book were reproduced from this version). The flat version was then tilted in order to create a view of the area from an angle 29 degrees off the horizon. Shadows, textures, and colors were added to represent a view that one might see from space.

Geyser Basin is the world's largest geyser, but it erupts irregularly—sometimes once a day, sometimes once a year. Flowing across this scalding plateau is the Firehole River, whose waters steam from volcanic activity just beneath the river bed.

Northeast of Yellowstone Lake are high, almost impenetrable peaks with names like Amphitheater Mountain, the Needle, Saddle Mountain, and The Thunderer, and from their narrow valleys, Soda Butte, Cache, and Miller Creeks all rush into the Lamar River.

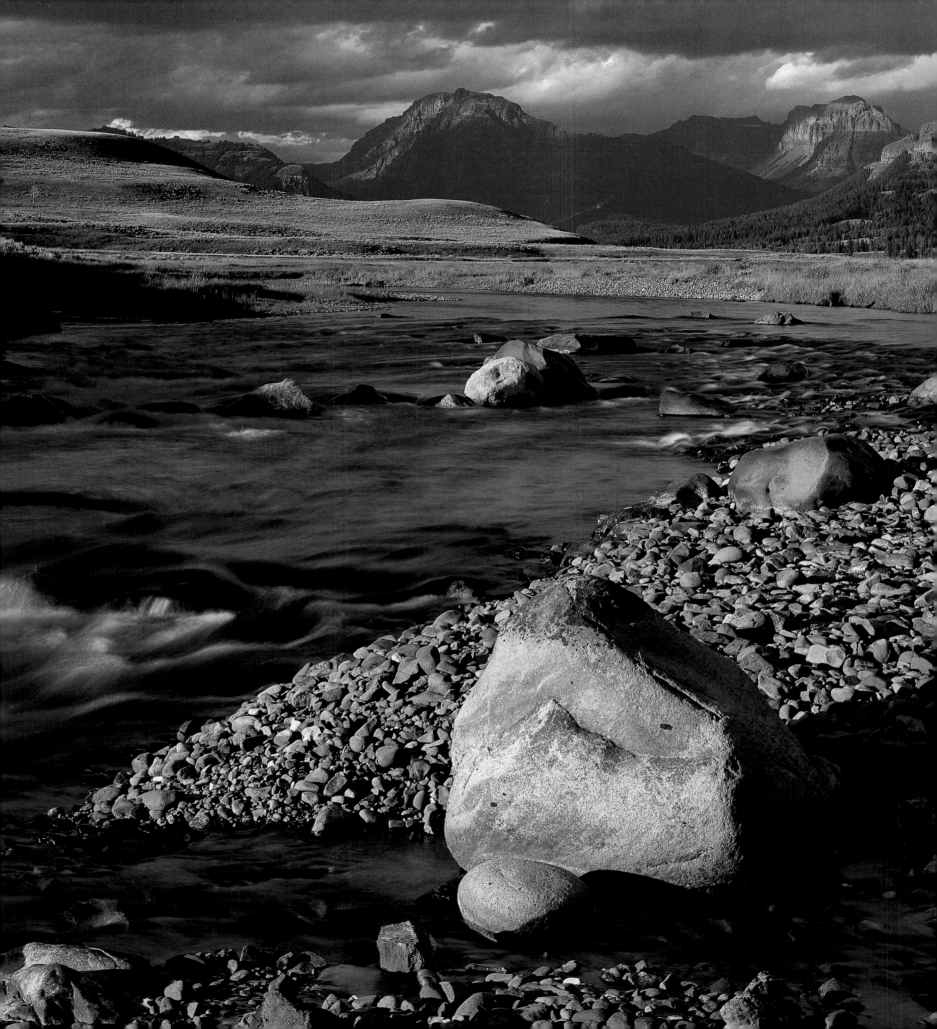

We rode all day, ten hours through meadow after meadow of wildflowers. The park was one garden made up of Indian paintbrush, mountain gentian, bluebells, arnica, elephant head, penstemon, and western coneflower, whose bald heads looked like the shaven heads of monks. At dusk, a pair of sandhill cranes danced by a narrow stream that leaked into a lake of pink thunderclouds. Killdeer and snipes burst up out of reeds, and a hatch of mayflies descended through them, hovering over trout waters. The last hard rays of the sun divided up the sky.

Yesterday we saw bison graze—their big heads seemed too big to be satisfied by mere blades of grass. How is it possible to fill up such an animal? Herds of antelope ran into herds of elk, who in turn ran the opposite direction. As the sun faltered, pairs of ducks flew over, returned, and landed on lakes, their numbers doubled and made pink in the reflection. Then a storm cell let down a black funnel of rain, flashing and buzzing with lightning.

An old friend who is an outfitter needed help moving his camp and fifteen head of packhorses into the park, and so I volunteered. In our gear was a cook tent, sleeping tents, kitchen equipment, sleeping bags and pads, and seven days' worth of food: beans, precooked meat, durable vegetables such as onions, potatoes, and cabbage, pasta, fruit, two loaves of bread, peanut butter and jelly, pancake mix, a few eggs wrapped individually in dishtowels, coffee, lemonade, tea, and cookies.

Storm clouds loom over the Lamar River as it winds past peaks in the northern range of the park.

JOURNEY INTO THE WILD

We started out at Pacific Creek, rode north by northeast crossing the southern boundary between Teton National Forest and Yellowstone, and followed the Yellowstone River north crossing Thorofare and Lynx Creeks and riding alongside a steep, west-facing mountain called The Trident.

The first night we made camp late, not bothering to set up a cook tent or sleeping tent, but laying our bedrolls down under a canvas tarpaulin pulled tight over a ridgepole. After eating we hung our boxes of food and personal effects, including toothpaste and the candy and coughdrops we carried in our pockets—anything that might smell like food to a bear. Long ropes were flung over a second ridgepole, then, hand over hand, the boxes were hoisted fifteen feet in the air. After, we skidded "evening logs" into camp, roping them like calves and dragging them to the fire. These would burn all night to help scare bears away. Then we lay out our bedrolls—the traditional white canvas envelopes into which our sleeping bags fit—a protective covering from dew, rain, and snow that cowboys have been using since they rode into the West.

The next day it was hot and calm. We toasted bread over the fire and scrambled a few eggs—it's best to eat the perishables early on. Then we packed up camp, balancing panniers, covering them with "mannys"—canvas covers—and securing them with ropes tied into squaw hitches and double diamonds. Once loaded, each horse was tied to the saddle of the horse in front of it, and from our own saddle horses we each led a packstring. Up the Yellowstone River we went, continuing north where it glides so langorously, it looks like liquid ice.

We were not too many miles from the source of the Yellowstone River, and it was still only three or four feet across—not a river at all, just a deep, clear stream. A little farther ahead, where the current goes smooth and fast, two black-headed ducks flew by so low to the water they almost ran into a fallen log, then turned their heads back when sandhill cranes squawked. Off my horse, I sat on a gravel bar next to a dry channel where this river once ran and watched as the ducks flew back, dripping with water after their swim.

The second night we camped near the park's southern boundary on the edge of Yellowstone Meadows. Walls of mosquitoes rose up. I tied a scarf over my mouth and nose after swallowing a few thousand. It seemed impossible to get away from them; to stop moving made it worse. We built a campfire before dark, hoping the smoke would scare them away. It helped, but it wasn't until nightfall that the siege slowed down. Then, as the moon rose, volcanic cliffs loomed. In so vast a place, our single campfire was a smoke signal no one would see.

Dog-song, coyote. The sun rose. A lone coyote loped through the meadow, slowed, lifted his head to howl, then trotted on. Sandhill cranes clucked and flew up. A hidden coyote sang—then I saw her, a young female whom the male joined. I saddled the wrangle horse and rode off to look for the other animals. It was cold. I sensed the faint shudder of mercury falling. Riding through willows, I spooked a moose, then answered back to the coyotes who, in turn, responded.

You cannot ride in Wyoming without noticing animal tracks. They lie before

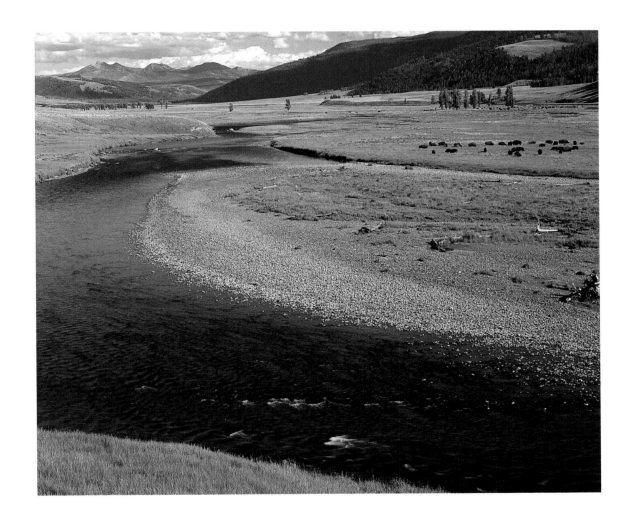

Bison graze in verdant meadows along the Lamar River.

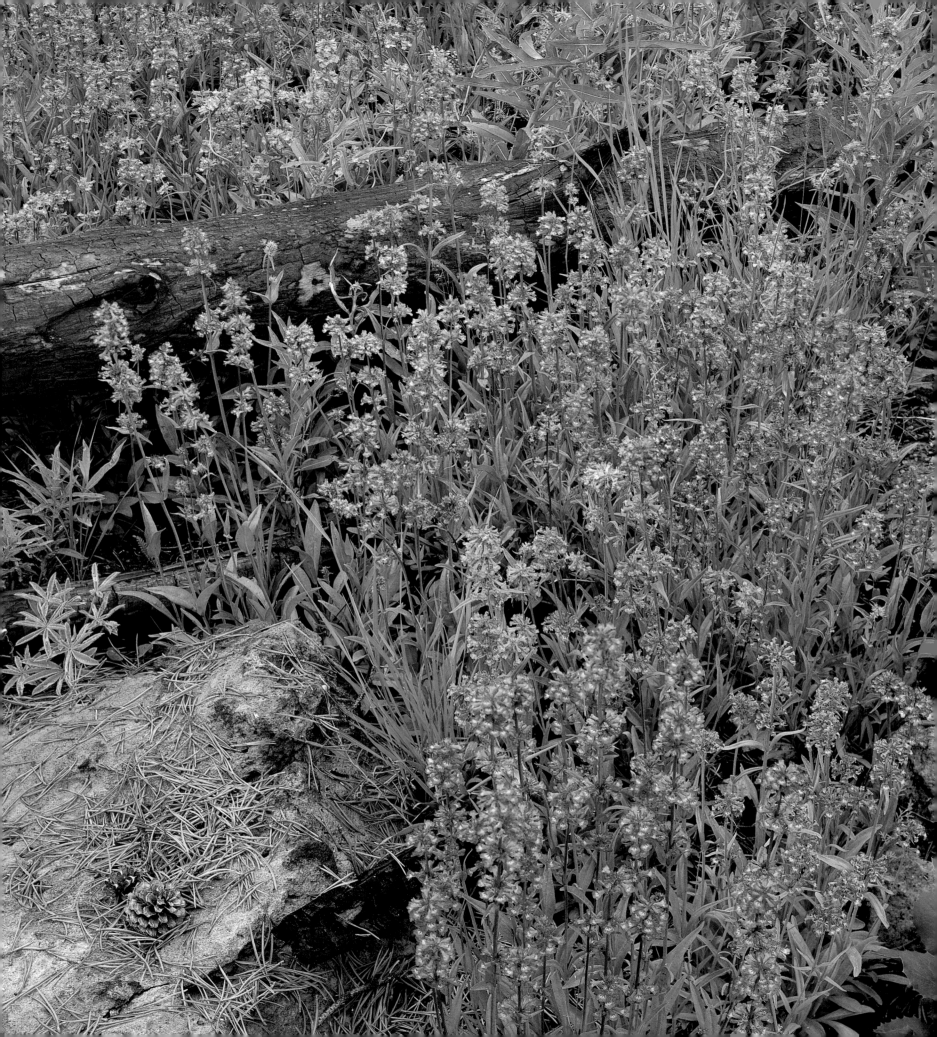

you like maps: a grizzly had been by, a cow elk and calf, and a few moose, coyotes, rodents, birds. I brought the horses back and they were given grain in camp.

Pancakes were consumed, a bridle and a pair of hobbles were repaired, books were read, and walks were taken: we, the living, walking through the standing dead of burnt trees. A bear bell clanged against my thigh—a small bell worn to frighten bears, though I'm quite sure it doesn't. The sound flushed meadowlarks from ground nests in tall grass. Three white pelicans played, their prehistoric shadows crossing my path, and circled an island of unburnt pines before crossing the edge of timber, white against black. Sandhill cranes walked the trail in front of me, eating grasshoppers, and in every tiny pond, families of ducks—mothers, fathers, and five or six ducklings—circled, then hid.

Where fire had burned willows, bright red fireweed, purple lupine, and lacelike Indian rice grass flourished, and everywhere else there was the low-to-the-ground Idaho fescue, bluebunch wheatgrass, timothy, red top, yarrow, purple aster, dark green sedge grass near the streams, and elk thistle, whose thick stalks we cut, peeled, and sliced like celery into the dinner salad. The river cut through the meadows like a clear knife, and I inventoried all those following it: three pair of mergansers, diving ducks and wood ducks, dippers, muskrats, and skating waterbugs.

In July, little penstemon grows tall on timbered slopes and in moist meadows.

That close to its source, the river was all oxbows, a ribbon that had been dropped. Its bends were shrouded in tall reeds, then taken up by the sun again before descending downstream. By midday, the air, a clear indigo, swam with mosquitoes, and above their masses, rafts of clouds obscured the sun until the day cooled. I walked among pines whose trunks had been blackened by fire into charred thrones. Upstream, a migration of mountain bluebirds flew from meadow to trees and back to meadow again in a single blue cloud.

Before dark, we made dinner: meatballs, rice, salad, bread, cookies, and strong coffee made cowboy style, with three heaping kitchen spoons of coffee dumped into the pot, boiled, then simmered after a stream of cold water had been poured in to tamp down the grounds.

At dawn, two moose grazed through mist rising on the river. They appeared and disappeared, and after a while I wondered if I had imagined them. The "karooo" calls of sandhill cranes rang so deeply they sounded like bells. Having mated in May, and hatched their eggs, they would soon migrate south to Mexico via the Teton Basin, the Uinta Mountains, and the San Luis Valley in Colorado.

As I rode one afternoon, just to see what I could see, a great gray owl spooked out of timber, and kestrels patrolled fields of mice hidden under wildflowers. Days earlier, at Yellowstone Lake, it had been ducks that had held my interest: twelve pairs of nesting loons, buffleheads, mergansers, goldeneyes, harlequins, ringnecks, teals, northern shovelers, pintails, mallards, and grebes, as well as shorebirds like white pelicans, who unlike their coastal cousins, the brown pelicans, swim to catch food instead of diving for it.

But now, deep inside the park, I watched a prairie falcon take a squirrel that was

accidentally dropped by a red-tailed hawk, while peregrine falcons dined on purple swallows darting over the water. Peregrines arrive in early April. Ten nesting pairs have been counted in the park, and soon they'll be taken off the endangered species list. After that, the park ornitholgists will help monitor them for the requisite five years to make sure their population continues to increase.

The next morning it rained. We ate pancakes with watery syrup. Water from my cowboy hat dripped down my spine, and the seat of my saddle was wet under my long yellow slicker. But after long droughts and dry, fiery summers, we welcomed the rain. My horses slipped in muddy tracks, sometimes dropping to their knees. Though I knew it was from losing their footing, I liked to think it was in thanks for rain.

The coyotes who had welcomed us called out as we left. Their haunting cry opened the morning to stillness after the storm. There was no wind. The winding Yellowstone River, still so narrow, looked like a throat trying to control words, then finally went straight, releasing song.

In midafternoon we followed a steep trail that traversed a mountain. Rain began again. One of the packhorses in front of me slid, fell, and rolled down the hill, taking the others with him. Steve and I dove off our horses, sliding down the hill on the heels of our boots, slowed only by spurs. We both had pocketknives out by the time we reached the horses. The strings by which they are tied to each other are intentionally flimsy and usually break. For some reason these didn't, and we both began cutting.

The lead horse had rolled his feet under a log. After a few tries we were able to pry him free. At first he didn't move. We both had the same awful thought: his legs are broken. But he was an old horse, and caution had saved his life in the mountains many times. He lifted his head, grunting, eyed us, then stood. His only injury was a deep cut above his eye.

Once freed, the other packhorses were standing. The packs had burst apart, and part of the kitchen load had been thrown around on the ground. I gathered pots and pans, knives and forks, while Steve settled the horses. We repacked them, then, one by one, led them up the cliff to the trail.

Packhorses are built to withstand such rigors. They are thick-boned, thick-skinned, patient, mountain-smart, and rarely get badly hurt. Still, we were lucky. It began raining again, and the only thing to do was to continue on. To our right, which was east, the claws of the mountain formation called The Trident dug in, and the long narrow valleys, like green fjords, were swallowed in clouds. Just above us, it had snowed.

That afternoon, we crossed the park line and camped in a tiny meadow. The rain had sent the mosquitoes away, and we set up camp quietly, quickly. I unpacked the veterinarian kit, filled a syringe with 20 ccs of combiotic, and gave the horse with the head wound a shot. We inspected each horse carefully—legs, bellies, heads—for any other wounds and applied salve to the few scrapes we found.

Like all good cowboys, Steve castigated himself for the wreck. "I was going too

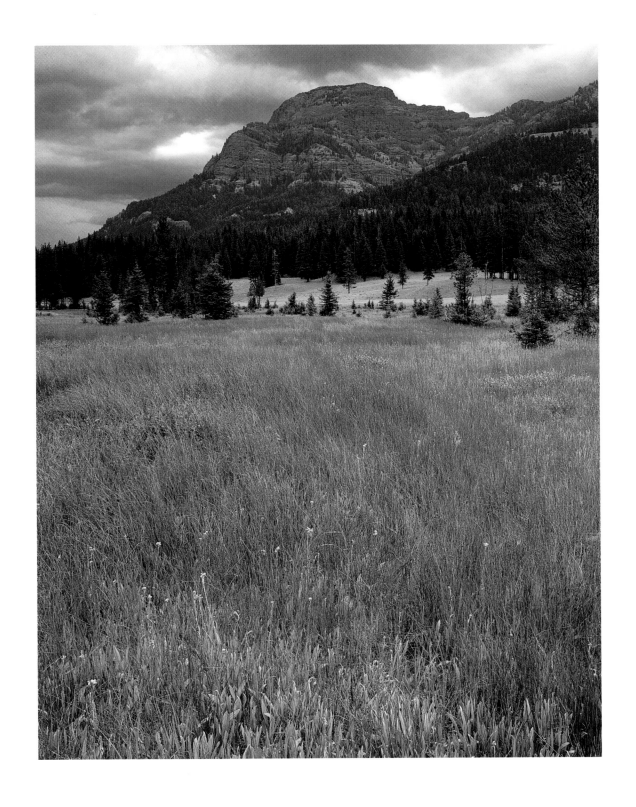

Sedge, wildflowers, and many varieties of native grasses grow thickly below Abiathar Peak—part of a vertiginous amphitheater of mountains wedged into the northeast corner of the park.

*S*torm clouds hover
over Dunraven Pass.
In the summer, cold
afternoon rains
are common.

fast; I didn't look back enough; I was daydreaming . . . "

"It was slippery," I reminded him, "And the trail was bad."

We made dinner and went to bed early.

In the morning, we discovered we had camped in prime grizzly habitat—though it's hard to avoid—and found grizzly tracks circling the meadow. We tracked the bear, whose wanderings led us up into a cirque, around berry bushes, down to the stream for fish or water, and up the trail again. Then we smelled her. In a loud voice Steve said, "Let's back up . . . just walk backwards for awhile."

"Okay," I agreed, my heart beating fast.

There was the sound of chuffing. Then I saw the back of the bear, her fat rolling as she ran from us. We turned and walked the few hundred yards back to camp.

"Maybe we better move on," Steve said casually.

Following the Yellowstone River north we turned west at Lynx Creek, along the steep edge of Two Ocean Plateau. It's here, on the Continental Divide, that mountain streams fall off this spine to flow either into the Atlantic or the Pacific Ocean.

Four hawks dove down, whistling, and ravens performed acrobatic turns midsky. We rode on. All afternoon we clambered down the creeks, over passes, down mountains. For a moment, a view of the Grand Teton was framed by pale clouds that folded together and hardened into rain. At this time of year, everyone says, "I can feel autumn in the air," though it is still August. But it was true. Pine winds wafted down from the high peaks of Colter Peak, Table Mountain, and Mount Hancock, and a chill pervaded even my innermost layer of red long underwear.

At the end of the day, a water ouzel dipped into creekwater, then flew south ahead of us as if to catch the sun—which, with its weakened rays, was already sliding south on the horizon as if to deliver Yellowstone back to winter. And indeed, by evening, the rain had turned to a light snow.

Two days later, we rode in the direction of the trailhead.

I had not wanted to go home. Far inside the deep quiet of the park, I understood that this place is truly a living organism, fashioned by stochastic rhythms of volcanism, ice ages, wildfires, rainstorms, winds, and blizzards.

Everywhere in the park death is replaced by life and life by death, and mountains, lakes, talus slopes, petrified forests, and every community of plants, each herd of animals, every migration of songbirds and shorebirds that soars through is connected.

The biological richness of Yellowstone once existed everywhere in the world. Now we've traded biological wealth for paper money and technology. As a result, all we have left are these island habitats, and these are shrinking. We must do what we can to help restore the broken and defiled lands between these beautiful islands and understand that, when we travel through this fine wilderness, we are walking on the back of a living being.

ACKNOWLEDGMENTS

After many years of travel in and around Yellowstone Park, from 1976 through 1994, the area remains in my mind as a nation: a high, floating empire of great beauty, complexity, and wildness. We must cherish this place, go to it as pilgrims, and honor its wild solitude.

Many thanks go to those who have let me tag along or have traveled with me, showing me the wonders of the place. Among them, the park biologists, botanists, naturalists, and ornithologists, especially Stuart Coleman, Don Despain, Terry McEneaney, George Robinson, Marty Murie and Franz Camenzind; geologists and friends Robert Palmquist and David Love; and Press Stephens and other guides who took me to the sources of rivers and the tops of mountains and through miles and miles of wildflowers.

Many maps and books have been helpful to me, especially *For Everything There Is a Season*, and *The Track of the Grizzly* by Frank Craighead; *A Field Guide to Western Birds* by Roger Tory Peterson; *Birds of Grand Teton National Park* by Bert Raynes; *Small Mammals of the Yellowstone Ecosystem* by Donald Streubel; *Yellowstone Vegetation* by Don Despain; and *A Field Guide to Rocky Mountain Wildflowers* by Craighead, Craighead, and Davis. There were many other excellent sources I depended on, of course, but these were my compass points along the way. Any errors and misconceptions are my own.

GRETEL EHRLICH
Gaviota, California

The setting sun paints Alum Creek pink in the wide Hayden Valley.

We would like to acknowledge and thank Stan Osolinski for the help and information he so willingly gave us and Sandy Nykerk for her hospitality and warm showers.

WILLARD AND KATHY CLAY
Ottawa, Illinois

INDEX